wild tea cosies

To Julian, who loves me best.

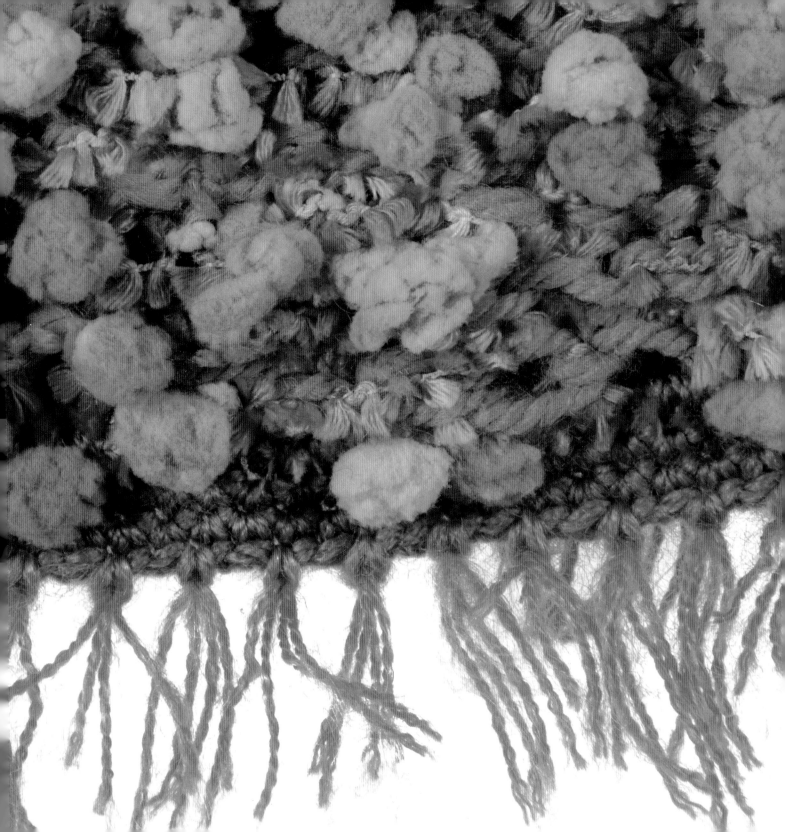

wild tea cosies

24 patterns with step-by-step instructions

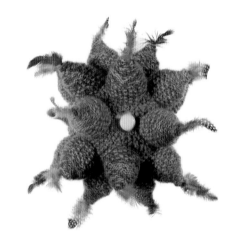

LOANI PRIOR

Search Press

WILD TEA COSIES
First published in Great Britain 2008
Search Press Limited
Wellwood
North Farm Road
Tunbridge Wells
Kent TN2 3DR

Reprinted 2009

Originally published in Australia in 2008 by
Simon & Schuster (Australia) Pty Limited

ISBN: 978-1-84448-418-8

Cataloguing-in-Publication data is available from the British Library.

Cover and internal design: Avril Makula, Gravity AAD
Photographer: Mark Crocker
Stylist: Matthew Crocker
Assistant stylist: Jonathon Hannon
Typeset in 10 pt on 14 pt Melior
Produced by Phoenix Offset. Printed in China.

10 9 8 7 6 5 4 3 2

Acknowledgments

I do like to read the acknowledgments in books and I always smile, well smirk really, at all the gushing that goes on in these few lines. It's just a little craft book after all. It's not earth-shattering or mind-blowing. There will be no epiphanies, no revelations. The world is not changed. So what is all the fuss about?

Well the fuss is all about the lovely things that happen when you ask people to join you in your endeavour. People, all sorts of people, step up to the plate and give whatever you need them to give. Gifts of time, expertise, encouragement. Given generously. Given joyously. So that your book, your treasure, will be the best it can be.

The fuss is all about my friends who point and laugh and wag their heads in disbelief at my designs, egging me on to brighter and funnier things.

The fuss is all about the test knitters, Ellen, Nicole, Hari and Wendy. What a surprising treat to see my designs knitted up in your honest and dedicated hands. And all about Mary and Dawn, who stowed treasured, embroidered table cloths for just this occasion.

The fuss is all about the stylist, Matt, who fussed endlessly (but not needlessly) about the hue of the table cloth, the lie of the spoon, the bite of the biscuit, the glint of the light. And Jonathon too, a most fastidious assistant fusser.

The fuss is all about the photographer, Mark, who brought his gentility, his sense and sensibility, and his large gift of time.

The fuss is all about Glenda, a publisher whose first smile I could hear down the line as she said yes she would like to see my tea cosies. And all the other smiles since.

The world is changed. My world. The small things changed it. Made it better. Of course I am proud that there is a book in the world with my name on it. Even if it is a little craft book. I am proud, but mostly I am buoyed by all the gifts along the way.

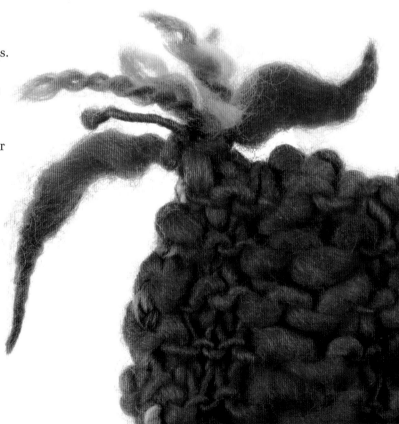

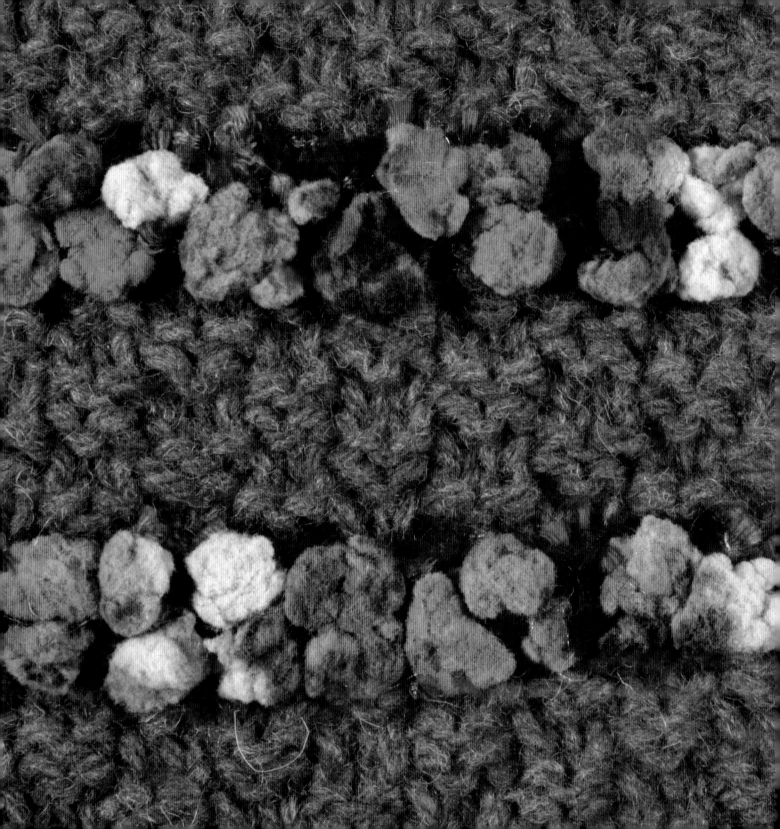

Contents

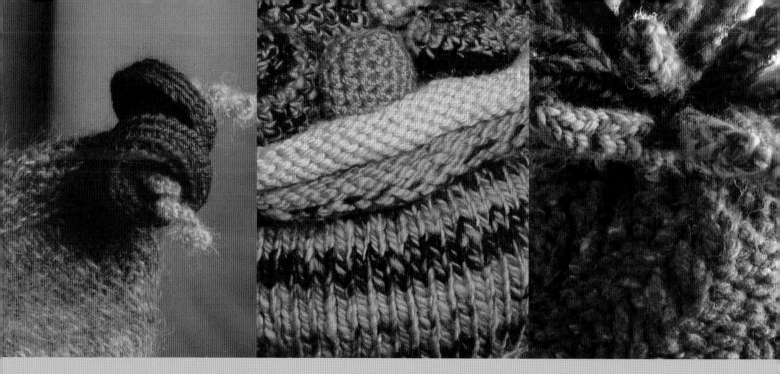

Introduction

I'm glad you are reading this introduction. It is a very useful introduction. It tells you stuff you need to know. But careful …

KNITTING IS ADDICTIVE

Wool shops, wool shops, I love them. I'm like a girl in a lolly shop — eyes wide bright. What shall I buy? Not satisfied with just one colour or texture, I want everything. 'What's your project, madam?' There is no project. Just a greedy stash: a palette of paints to replenish.

Barely an evening goes by in my house without knitting, crochet or spinning. A 1950s varnished drinks trolley is my toolshed, sitting beside my comfy chair in the living room. Everything is at hand: reading light, knitting needles, darning needles, crochet hooks, tape measure, scissors, pins, buttons, beads and wool for at least three projects (often a tea cosy).

REMEMBER, TEAPOTS ARE LIKE WOMEN …

… they come in many shapes and sizes. My six-cup teapot is round and plump with a generous mound at her top. The cosies in this book are made to show off her voluptuous figure and perky personality. Other six-cup teapots may be less well-endowed, taller or shorter, but the one-size-fits-all patterns in this book should still suit.

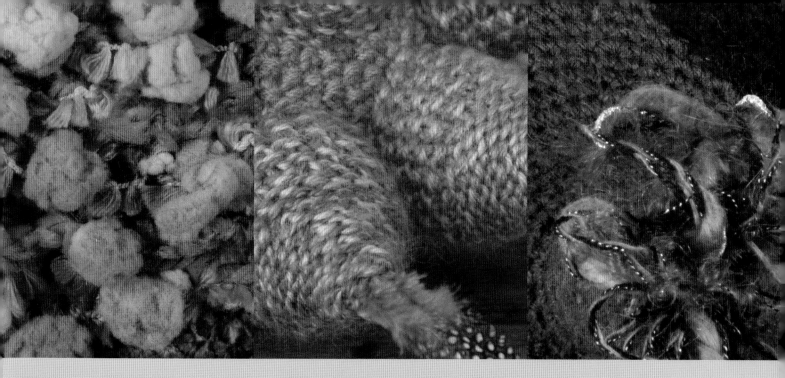

ALWAYS READ A PATTERN FROM GO TO WHOA

This way there won't be any surprises. Make notes if you need to. Temporary sticky notes are great if you don't want to write in this gorgeous book.

TO SWATCH OR NOT TO SWATCH?

Any self-respecting knitter will make a gauge swatch to check their tension, but in tea cosy land, if you knit a gauge swatch you have almost completed one side of a tea cosy. I tend to trust my eye and compare the work often with the actual teapot. If I get it wrong I pull it undone. It's only a tea cosy.

On the other hand, some fancy yarns don't unravel all that well once knitted together. If you are worried, do knit a gauge swatch.

AND WHERE DOES INSPIRATION STRIKE?

Some of my tea cosies have been requested for a themed party or celebration. Some are inspired by the beach or garden. Some jump out at me from my yarn stash yelling 'knit ME!'. Some designs are the result of running out of one yarn and having to choose another. Some shapes are accidental, not quite matching the picture that I had in my mind's eye. Some end up on the cutting-room floor.

They all make me smile and are loved for that reason alone. My hope is that you will approach each pattern as an inspiration rather than a paint-by-numbers project. Mix and match. Change yarns. Change colours. Experiment! Go wild!

Sock it to me

Knitted in the round — on four double-pointed needles — the tea cosies on these pages are cylindrical in structure, with openings for the spout and handle. A circular lid section holds an infinite number of fruit, flowers, feathers and flounces on top.

HINTS FOR EASY KNITTING IN THE ROUND

Remember that you are not really knitting with four needles. Two of the needles are merely holding stitches that you are not using at the moment. You are still only knitting with two needles at a time and one strand of yarn.

 The most common mishap when managing four needles is to add a stitch as you change from one needle to the next. To avoid this, check the position of the yarn. If the next stitch is purl, the yarn will need to be at the front of the two needles you are using. If the next stitch is knit, the yarn will need to be behind the two needles you are using, exactly as if there were only two needles.

USING DOUBLE-POINTED NEEDLES

Use four or five double-pointed needles, depending on the size of the work. If you are using four needles, arrange the stitches evenly onto three needles and use the fourth needle to knit the stitches from Needle 1. Needle 1 then becomes the working needle, knitting the stitches from Needle 2, and so on.

STUFFING THREE-DIMENSIONAL PIECES

Keep a small bag of polyester fibre fill on hand for stuffing. Tear off small amounts of fibre fill and push it into the three-dimensional parts of the tea cosy. Continue adding small amounts until the shape is firm.

STOCKING STITCH OR GARTER STITCH?

When you work knitting stitch in ROUNDS, you produce stocking stitch.
When you work knitting stitch in ROWS, you produce garter stitch.

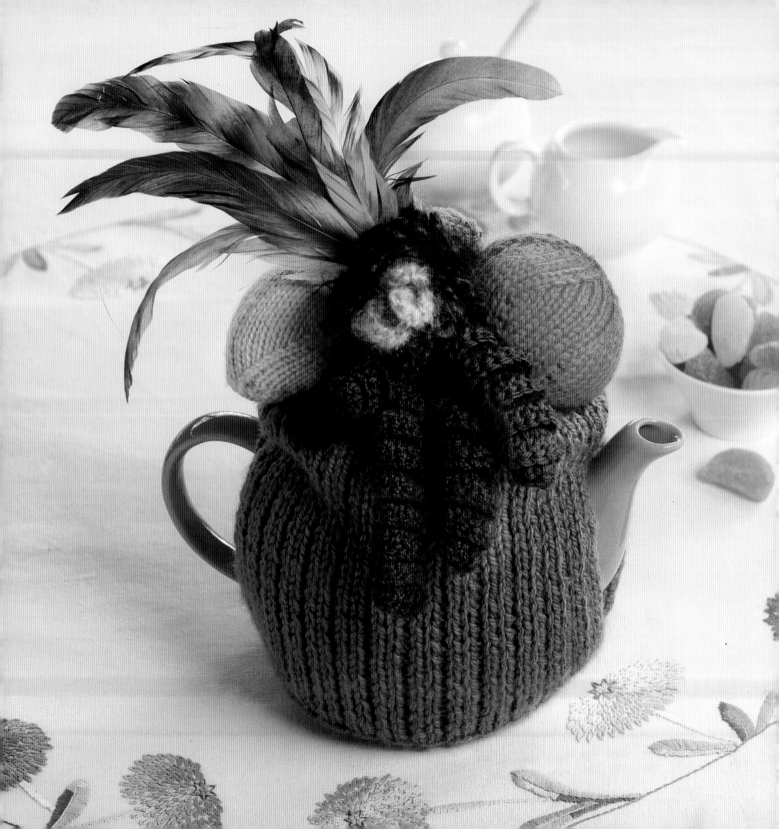

Carmen Miranda

Knitted body and fruit
Crocheted or knitted grapes
Crocheted and knitted flower

She was my first tea cosy, Carmen Miranda, designed at the behest of a friend for his party — a celebration of the bearing of fruit. Steve's lime tree produced one lime after a long seven-year wait. (Any excuse for a party!) And that, simply, was my brief.

SIZE
Six-cup teapot

MATERIALS
Three 50 g balls of 8 ply yarn, dusty lime green
One 25 g ball of 8 ply yarn, citrus orange
One 25 g ball of 8 ply yarn, lemon yellow
One 25 g ball of 8 ply yarn, grape purple
One 25 g ball of loopy-textured yarn, crimson
One 25 g ball of mohair yarn, mandarin
Five feathers
Polyester fibre fill

EQUIPMENT
Five 5 mm double-pointed needles
Four 4 mm double-pointed needles
4 mm crochet hook
Scissors
Darning needle

The cosy and lining is worked in one piece, then folded in on itself to create the lining.

BASE
Using 5 mm double-pointed needles and 8 ply dusty lime green yarn, cast on 78 stitches — 20, 19, 20, 19 stitches on each needle. Join in a round as follows, making sure the stitches are not twisted around the needles.
Rounds 1–4: *K2, P1*, repeat * to * until the round is complete.

SIDES
Row 5: Turn the work so that the wrong side is facing you. Work 39 stitches, continuing the rib pattern (P2, K1), across two needles.
Row 6: Turn the work so that the right side is facing you. Continue the rib pattern (K2, P1).
Rows 7–24: Repeat rows five and six for 18 more rows. Break off the yarn, leaving a long tail for darning later.
Repeat rows 5–24 with the remaining stitches on the other two needles. Do not break off the yarn.

TOP AND TOP LINING
Row 25: Join the sides together again by knitting in the round once again. Continue working the rib pattern (K2, P1) for 30 rounds.

SIDES (LINING)
Repeat rows 5–24 as above.

BASE (LINING)
Repeat rounds 1–4. Cast off.

13

LEMON AND LIME

Make one each in dusty lime green and lemon yellow yarn.

Using 4 mm double-pointed needles and 8 ply yarn, cast on five stitches. This is not knitted in the round; however, you will need to add in the double-pointed needles as the number of stitches increases.

Row 1: Purl.

Row 2: Increase knit wise into every stitch.

Row 3: Purl this row and each alternate row.

Row 4: *K1, increase into next stitch*, repeat * to * to end.

Row 6: *K2, increase into next stitch*, repeat * to * to end.

Row 8: *K3, increase into next stitch*, repeat * to * to end.

Row 10: *K4, increase into next stitch*, repeat * to * to end.

Row 12: *K5, increase into next stitch*, repeat * to * to end.

Rows 13–17: Continue in stocking stitch (purl odd rows, knit even rows).

Row 18: *K5, K2 tog*, repeat * to * to end.

Row 19: Purl this row and each alternate row.

Row 20: *K4, K2 tog*, repeat * to * to end.

Row 22: *K3, K2 tog*, repeat * to * to end.

Row 24: *K2, K2 tog*, repeat * to * to end.

Row 26: *K1, K2 tog*, repeat * to * to end.

Row 28: K2 tog, repeat to end.

There will be five stitches remaining. Cut the yarn, leaving a long tail. Thread the tail into a darning needle, gather up the five stitches and sew the edges together. Stop sewing 2 cm

from the end and stuff the lemon or lime firmly with polyester fibre fill. Finish the seam. Use your hands to mould the fruit shape.

ORANGE

Using 4 mm double-pointed needles and 8 ply citrus orange yarn, cast on seven stitches.

Rows 1–12: Work as for the lemon and lime.

Row 13: Purl.

Row 14: *K5, K2 tog*, repeat * to * to end.

Row 16: *K4, K2 tog*, repeat * to * to end.

Row 18: *K3, K2 tog*, repeat * to * to end.

Row 20: *K2, K2 tog*, repeat * to * to end.

Row 22: *K1, K2 tog*, repeat * to * to end.

Row 24: K2 tog, repeat to end.

There will be seven stitches remaining. Finish the orange as for the lemon and lime.

GRAPES

Make five twirls of different sizes to represent grapes. Twirls may be knitted or crocheted. Using 8 ply grape purple yarn, work twirls according to the instructions on page 110.

FLOWER

Using 5 mm double-pointed needles and crimson loopy-textured yarn, cast on 20 stitches. Knit 10 rows. Cast off. Roll the rectangle on the diagonal and stitch it together at the base.

Using a 4 mm crochet hook and mandarin mohair yarn, make 15 chain. Missing the first 2 ch, make 3 dc into each chain to end. Insert the curly stamen into the centre of the flower and stitch it in place at the base.

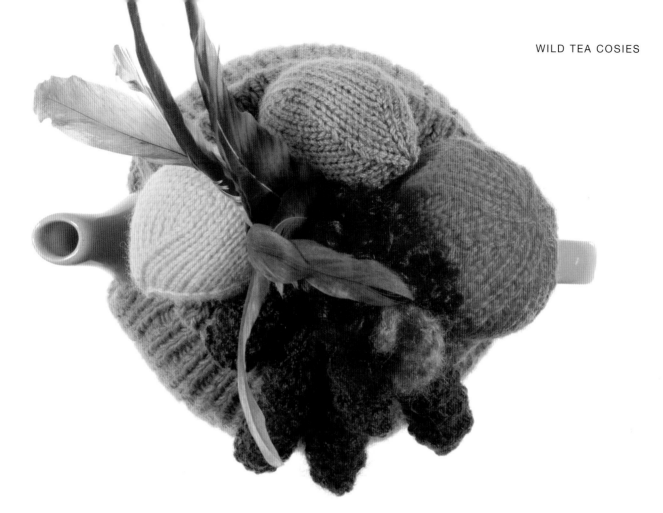

FRUIT TRAY

Make two circles. Circles may be knitted or crocheted. Using 8 ply dusty lime green yarn, work circles according to the instructions on page 107.

FINISHING

Fold the tea cosy sock in on itself, aligning the openings for the spout and handle. Sew the lining and the outer sock together at the edges of the spout and handle openings.

Place the tea cosy over the teapot with the folded edge at the top. Pin a fruit tray approximately 3 cm (or best fit) from the top of the fold. Sew the tray into position, securing it to both the inner and outer sock walls.

Arrange the fruit, flower and feathers on the tray and sew each item firmly into place. Keep checking that the arrangement is falling into place as you attach each item. Turn the tea cosy inside out and darn the loose threads into the bottom of the tray.

For a really professional look, sew the second tray into the inside top of the cosy to cover the darned threads.

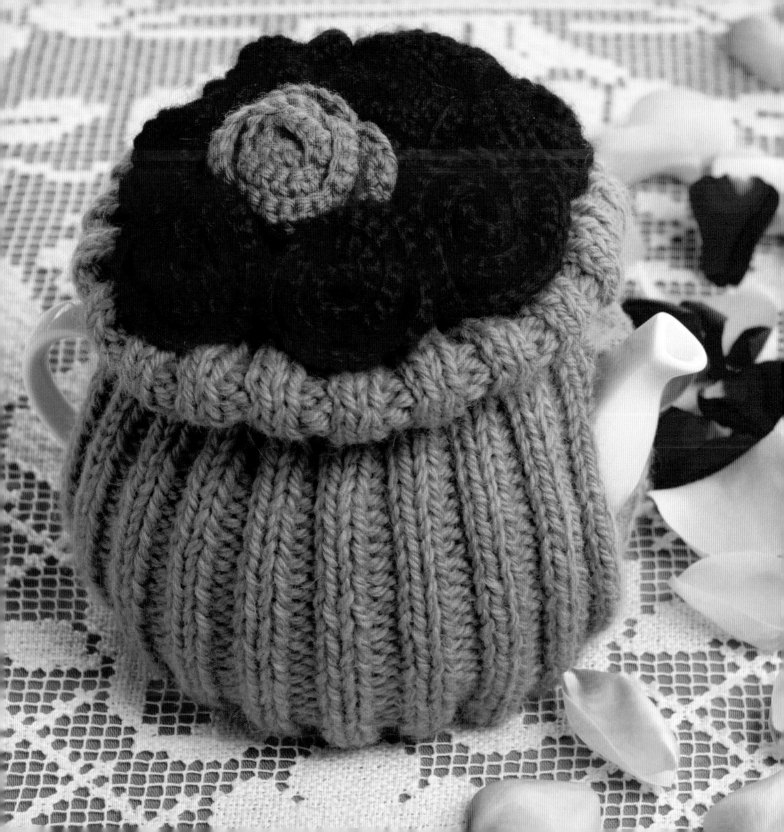

Rosie Posy

Knitted body
Crocheted roses

Roses are red.
Violets are blue.
Here's a tea cosy,
Just for you.

My favourite aunt was pretty chuffed with her bunch of roses. No wilting or fading. Well, not for many an afternoon tea yet.

SIZE
Six-cup teapot

MATERIALS
Three 50 g balls of 8 ply yarn, dusty olive green
One 50 g ball of 8 ply yarn, rose red
Small amount of 8 ply yarn, dusty pink

EQUIPMENT
Five 5 mm double-pointed needles
4 mm crochet hook
Scissors
Darning needle

The cosy and lining is worked in one piece, then folded in on itself to create the lining.

BASE
Using 5 mm double-pointed needles and 8 ply dusty olive green yarn, cast on 80 stitches — 20, 20, 20, 20 stitches on each needle. Join in a round as follows, making sure the stitches are not twisted around the needles.
Rounds 1–4: *K2, P2*, repeat * to * to end.

SIDES
Row 5: Turn the work so that the wrong side is facing you. Work 40 stitches, continuing the rib pattern (P2, K2), across two needles.
Row 6: Turn the work so that the right side is facing you. Continue the rib pattern (K2, P2).
Rows 7–24: Repeat rows five and six for 18 more rows. Break off the yarn, leaving a long tail for darning later.
Repeat rows 5–25 with the remaining stitches on the other two double-pointed needles. Do not break off the yarn.

TOP AND TOP LINING
Row 25: Join the sides together again by knitting in the round once again. Continue working the rib pattern (K2, P1) for 30 rounds.

SIDES (LINING)
Repeat rows 5–24 as above.

BASE (LINING)
Repeat rounds 1–4. Cast off.

ROSES

Make eight rose red roses and one dusty pink rose.
Using a 4 mm crochet hook and 8 ply yarn
make 39 chain. The pattern works in multiples
of four stitches.

Row 1: Skip the first 2 ch (counts as first dc) and
make 1 htr into the third chain from the hook, 1 htr
into next 2 ch, 1 dc into next ch. *1 htr into next
3 ch, 1 dc into next ch*, repeat * to * to end.

Row 2: 2 ch (counts as first dc), *2 tr into next
3 htr, 1 dc into next dc*, repeat * to * to end.

Row 3: 2 ch (counts as first dc), *1 dc into next 6 tr,
1 dc into dc of first row*, repeat * to * to end.

Tie off and cut the yarn, leaving a long thread at the
beginning and end of the pattern. Twist the work
round and round so that the petals fold outwards
from the centre. Sew together the base of the rose to
secure the shape.

ROSE BED

Make two circles. Circles may be knitted or
crocheted. Using 8 ply dusty olive green yarn, work
circles according to the instructions on page 107.

FINISHING

Fold the tea cosy sock in on itself, aligning the
openings for the spout and handle. Sew the lining
and the outer sock together at the edges of the
spout and handle openings.

Place the tea cosy over the teapot with the folded
edge at the top. Pin a rose bed approximately 3 cm
(or best fit) from the top of the fold. Sew the bed
into position, securing it to both the inner and
outer sock walls.

Arrange the roses on the bed with the pink rose in
the centre and sew each item securely into place.
Turn the tea cosy inside out and darn the ends of
the threads into the bottom of the tray.

For a really professional look, sew the second rose
bed into the inside top of the cosy to cover the
darned threads.

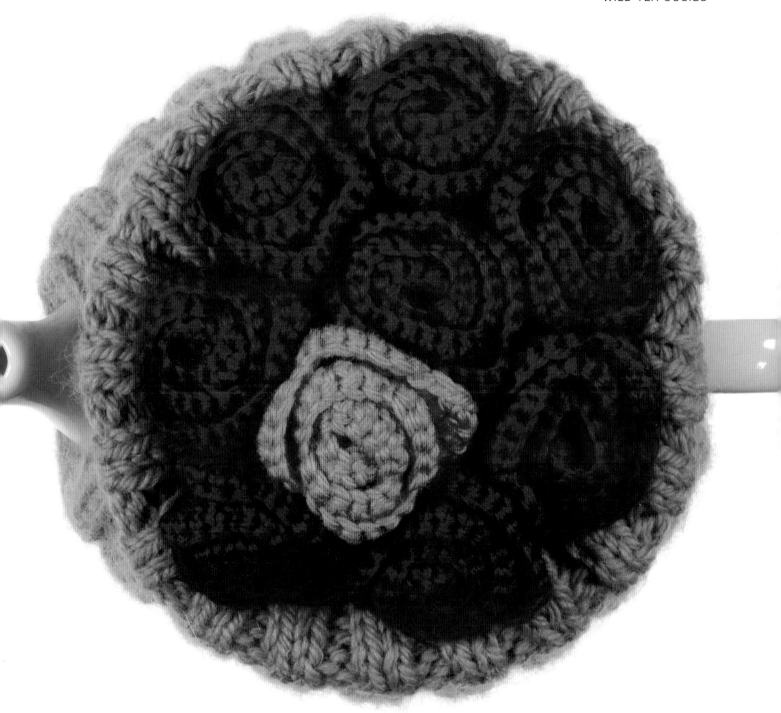

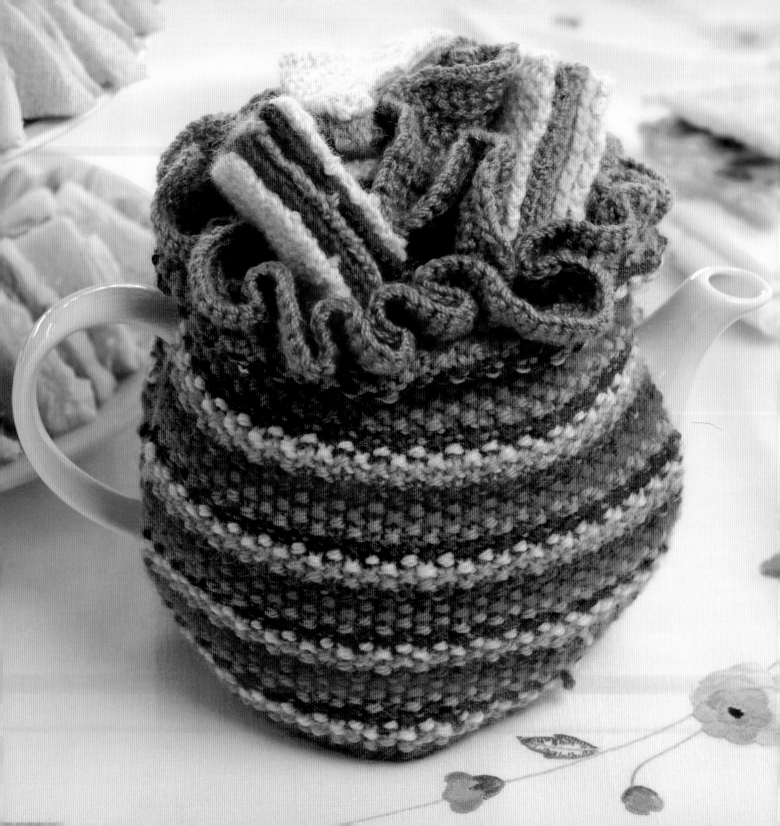

Sandwich, Anyone?

Knitted body and sandwiches
Crocheted or knitted lettuce

If you like, you can forget the tea cosy and just make the sandwiches. Fifteen little triangles of many colours, with every row worked in knitting stitch. A perfect knitting treat for young knitting fingers.

SIZE
Six-cup teapot

MATERIALS
One 25 g ball of 8 ply yarn, salami brown
One 25 g ball of 8 ply yarn, bread white
One 25 g ball of 8 ply yarn, tomato red
One 25 g ball of 8 ply yarn, tangerine orange
One 50 g ball of 8 ply yarn, lettuce green
One 50 g ball of 8 ply yarn, ham pink

If you can't buy 25 g balls of 8 ply yarn, buy 50 g balls and knit two tea cosies!

EQUIPMENT
Five 4 mm double-pointed needles
4 mm crochet hook
Scissors
Darning needle

The cosy and lining is worked in one piece, then folded in on itself to create the lining. Change yarn colour every two rows until you reach the lining part of the tea cosy sock. Work in pink from that point on. My colour pattern is brown, green, white, red, pink, orange.

BASE
Using 4 mm double-pointed needles and 8 ply salami brown yarn, cast on 80 stitches — 20, 20, 20, 20 stitches on each needle. Join in a round, making sure the stitches are not twisted around the needles. Work in moss stitch as follows.
Round 1: *K1, P1*, repeat * to * until the round is complete.
Round 2: *P1, K1*, repeat * to * until the round is complete.
Repeat round one and two.

SIDES
Row 5: Turn the work so that the wrong side is facing you. Work 40 stitches, continuing the moss stitch pattern (P1, K1), across two needles.
Row 6: Turn the work so that the right side is facing you. Continue the moss stitch pattern (K1, P1).
Rows 7–28: Repeat rows five and six for 22 more rows. Break off the yarn, leaving a long tail for darning later.
Repeat rows 5–28 with the remaining stitches on the other two needles. Do not break off the yarn.

TOP AND TOP LINING

Row 29: Join the sides together again by knitting in the round once again. Continue working the moss stitch pattern (K1, P1) for 30 rounds.

SIDES (LINING)

Choose a colour for the lining that you will not use much of in the decorations on top of the tea cosy and continue in garter stitch (knitting every row). Repeat rows 5–28 above, in garter stitch.

BASE (LINING)

Garter stitch four rounds. To work garter stitch while knitting in the round you will need to knit one round and purl one round. Repeat. Cast off.

LETTUCE LEAF PLATTER

Make one frilled circle. Frilled circles may be knitted or crocheted. Use 8 ply lettuce green yarn and work a frilled circle according to the instructions on page 107.

LETTUCE LEAF

Make one frill. Frills may be knitted or crocheted. Use 8 ply lettuce green yarn and work a frill according to the instructions on page 109.

SANDWICH TRIANGLES

Knit 15 triangles (six in white yarn and the remainder in green, brown, red and pink) to make three sandwiches.

Using 4 mm double-pointed needles, cast on two stitches. Knit 1 row. Increase at each end of the next and alternate rows until there are 20 stitches on the needle. Knit 1 row. Cast off, leaving enough yarn to darn the tail of thread into the work.

FINISHING

First darn all the tails of thread into the work.

Fold the tea cosy sock in on itself, aligning the openings for the spout and handle. Sew the lining and the outer sock together at the edges of the spout and handle openings.

Place the tea cosy over the teapot with the folded edge at the top. Pin the lettuce leaf platter into place with the frill escaping over the top edge, approximately five rows from the top fold. Sew the platter into place, securing the inner and outer sock walls to the platter.

Secure the sandwich parts together with one or two loose stitches, tying the yarn off between the inner layers. Arrange the sandwiches and the lettuce leaf on the platter and sew them securely into place. Darn the ends of the thread into the underside of the platter.

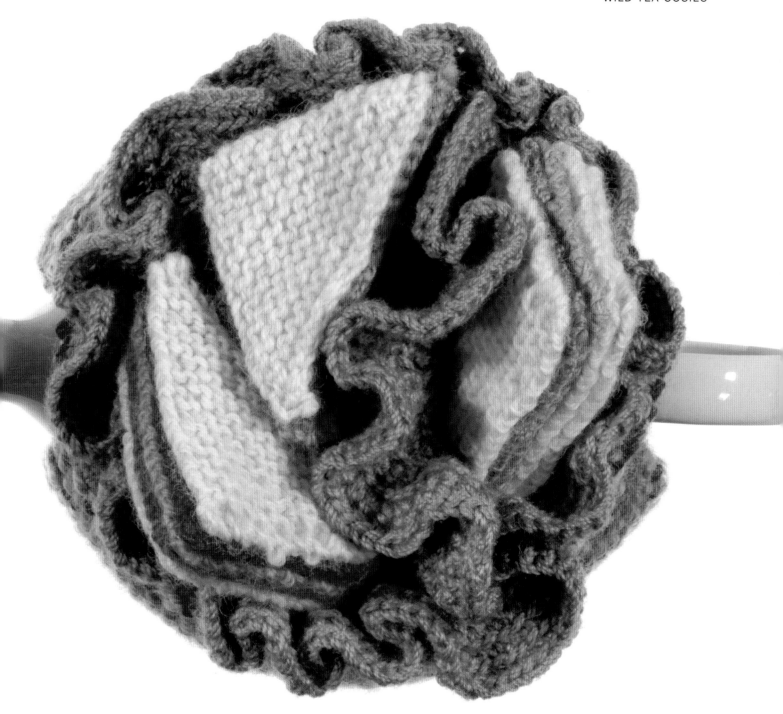

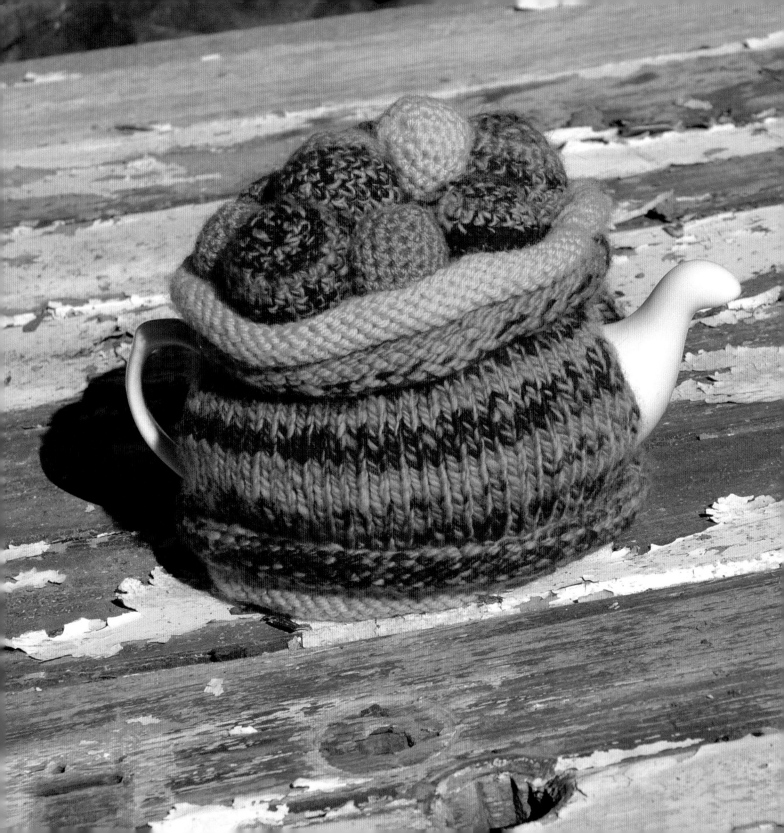

Roly Poly

Knitted body
Crocheted balls (or pompoms)

You have enough tea cosies? String the crocheted balls together to make a fabulous piece of neck art. Or use red, green and gold sparkly yarn to make Christmas baubles. Or crochet a ball using a 2 mm crochet hook and 4 ply cotton and then fill it with rice for a hacky sac.

SIZE
Six-cup tea pot

MATERIALS
Two 50 g balls of 8 ply yarn, rainbow-dyed
Two 50 g balls of 8 ply yarn, yellow
Small amount of 8 ply yarn, green

EQUIPMENT
Five 4 mm double-pointed needles
4 mm crochet hook
Scissors
Darning needle

The cosy and lining is worked in two pieces, with the lining slightly longer to allow it to spill out over at the top and bottom of the cosy. The lovely roll-up effect occurs when you begin working in stocking stitch from the first row.

BASE
Using 4 mm double-pointed needles and 8 ply rainbow-dyed yarn, cast on 68 stitches — 17, 17, 17, 17 stitches on each needle. Join in a round as follows, making sure the stitches are not twisted around the needles.
Round 1: Knit.
Round 2: Knit.
When knitting in the round, stocking stitch is created by knitting every round. Continue in stocking stitch for eight more rounds.

SIDES
Row 11: Turn the work so that the wrong side is facing you. Purl 34 stitches, continuing the stocking stitch pattern across two needles.
Row 12: Turn the work so that the right side is facing you. Knit 34 stitches, continuing the stocking stitch pattern.
Rows 13–32: Repeat rows 11 and 12 for 20 more rows. Break off the yarn, leaving a long tail for darning later.
Repeat rows 11–32 with the remaining stitches on the other two needles. Do not break off the yarn.

TOP
Row 33: Join the sides together again by knitting in the round once again. Continue working in stocking stitch for 10 rounds. Cast off.

LINING

Using 4 mm double-pointed needles and 8 ply yellow yarn, cast on 68 stitches — 17, 17, 17, 17 stitches on each needle. Join in a round as follows, making sure the stitches are not twisted around the needles.

Round 1: Knit.

Round 2: Knit.

Continue in stocking stitch for 12 more rounds.

Row 15: Turn the work so that the wrong side is facing you. Purl 34 stitches, continuing the stocking stitch pattern across two needles.

Row 16: Turn the work so that the right side is facing you. Knit 34 stitches, continuing the stocking stitch pattern.

Rows 17–36: Repeat rows 15 and 16 for 20 more rows. Break off the yarn, leaving a long tail for darning later.

Repeat rows 15–36 with the remaining stitches on the other two needles. Do not break off the yarn.

Row 37: Join the sides together again by knitting in the round once again. Continue working in stocking stitch for 14 rounds. Cast off.

ROLY POLY TRAY

Make two circles. Circles may be knitted or crocheted. Using 8 ply yellow yarn, work circles according to the instructions on page 107.

ROLY POLY BALLS

Make nine balls of different sizes and colours. If you don't crochet, use pompoms.

Using a 4 mm crochet hook, make 5 chain. Slip stitch to make a circle.

Round 1: 1 ch, 8 dc into circle. Mark the beginning of the round with a contrasting coloured yarn.

Round 2: Crochet into the back of the double crochet loop. *2 dc into next dc, 1 dc into next dc*, repeat * to * to end.

Round 3: *2 dc into next dc, 1 dc into next 2 dc*, repeat * to * to end.

Round 4: *2 dc into next dc, 1 dc into next 3 dc*, repeat * to * to end.

Round 5: *2 dc into next dc, 1 dc into next 4 dc*, repeat * to * to end (24 stitches).

Round 6: 1 dc into next dc, repeat to end.

Round 7: *Miss 1 dc, 1 dc into next 4 dc*, repeat * to * to end.

Round 8: *Miss 1 dc, 1 dc into next 3 dc*, repeat * to * to end.

Round 9: *Miss 1 dc, 1 dc into next 2 dc*, repeat * to * to end.

Before the opening gets too small, turn the ball inside out for a smoother texture. Stuff the ball firmly with polyester fibre fill.

Round 10: *Miss 1 dc, 1 dc into next dc*, repeat * to * to end (8 stitches).

Cut the yarn, leaving a tail, and thread the tail through a darning needle. Gather up the remaining stitches and pull the yarn tight. Mould the ball into a nice cylindrical shape.

For bigger balls, continue the increasing pattern until the desired circumference is reached.

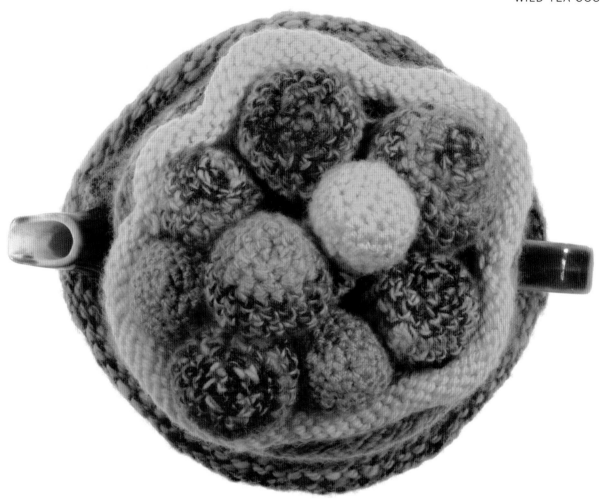

FINISHING

Place the lining inside the cosy with the right sides of both facing outwards. Sew the lining and cosy together around the spout and handle openings. Allow the stocking stitch to roll up at the top and bottom. Arrange the longer lining to sit above and below the shorter outer cosy. Fix the rolls into place with two or three loose stitches.

Place the tea cosy over the teapot. Pin a roly poly tray approximately 2 cm (or best fit) from the top of the lining. Sew the tray into position, securing it to both the lining and outer cosy.

Arrange the roly poly balls in the tray and sew each one securely to the tray and to the adjacent balls. Turn the tea cosy inside out and darn the ends of the threads into the bottom of the tray.

For a really professional look, sew the second tray into the inside top of the cosy to cover the darned threads.

Diagonal addiction

I love diagonal squares. I love how they grow out of two stitches. I love how much cleverer they look than straight up and down squares. I love how easy they are to knit. I love how two squares make a tea cosy and how 30 squares make a throw. I love how a little variation can make a big difference.

These are great patterns for using up those 8 ply ball ends from your stash.

INCREASING
Increase by knitting into the front and then the back of a stitch before slipping the stitch off the needle.

CHANGING COLOURS
Change yarn colours on rows without increasing in them. This will give you a much tidier edge than if you were to change yarn colours on an 'increase' row.

MARKING THE WRONG SIDE
Place a contrasting coloured thread as a marker on the wrong side of your work. The wrong side is the side facing you when you increase. This way you will not be constantly counting from the beginning each time you pick up the work.

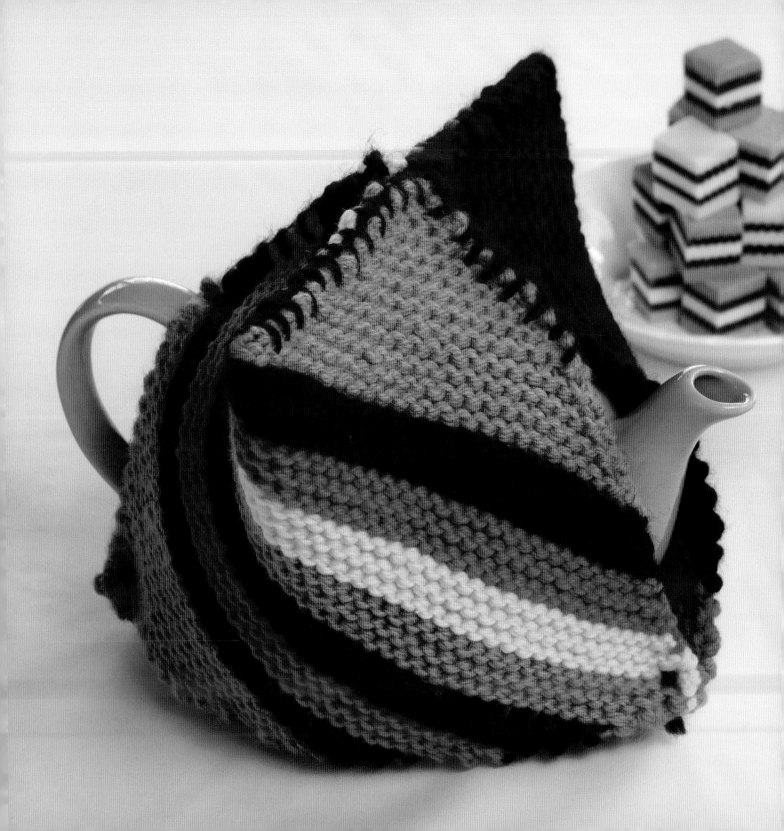

Liquorice Allsorts

Knitted cosy

Yellow, orange and clashing pink yelled 'knit ME!' from my stash. The blackest black I chose. The inspiration was all about colour, quickly followed by the memory of childhood treats.

SIZE
Six-cup teapot

MATERIALS
One 50 g ball of 8 ply yarn, black
One 50 g ball of 8 ply yarn, hot pink
One 50 g ball of 8 ply yarn, yellow
One 50 g ball of 8 ply yarn, orange

EQUIPMENT
Pair of 6 mm knitting needles (looser fabric)
Pair of 5 mm knitting needles (firmer fabric)
Scissors
Darning needle

COSY
Make two diagonal squares. Using 5 mm or 6 mm knitting needles and two strands of wool of the same colour, cast on two stitches.
Row 1: Knit.
Row 2: Increase in the first and last stitch of the row.
Row 3: Knit.
Row 4: Increase in the first stitch of the row, knit to the last stitch, then increase in the last stitch.

Repeat rows 3 and 4 for at least 20 rows before making your first colour change. Then change colour after every sixth row. Continue increasing until you have 50 stitches on the needle or until the edge of the knitting measures well across the base of the teapot.
Next row: Knit.
Next and alternate rows: K2 tog, knit to the last two stitches, K2 tog.
Decreasing at both ends of the row will create a square. To create a rectangle for a taller teapot you will decrease at the beginning of the row while continuing to increase at the end of the row. Keep measuring the height of the rectangle against the teapot. When you have reached the right height, begin decreasing at both ends.
When you have only two stitches left on the needle, cast off.

FINISHING
Sew all the ends of the yarn into the wrong side of the work.
Thread the darning needle with black yarn. Join the two squares together at the bottom corners with a single stitch under the spout and handle openings. Using blanket stitch, sew the side seams together above the spout and handle openings.
Fold the top of the tea cosy so that the side seams are together in the middle of the cosy. Work blanket stitch across the top of the cosy.

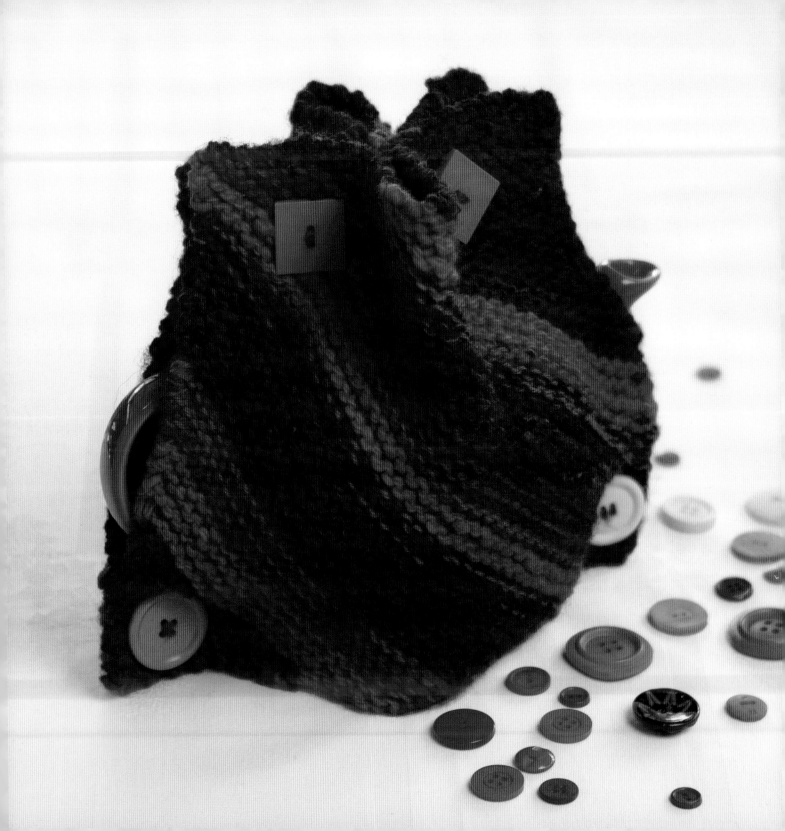

Red Comet

Knitted cosy

Knit, knit, knit. That's all — just knitting. And increasing at each end. And changing colours at whim. And decreasing at each end. What could be more comforting? What could be better? You'll have this jazzy cosy finished almost before you're ready for your next cup of tea!

SIZE
Six-cup teapot

MATERIALS
One 50 g ball of 8 ply yarn, brown
One 50 g ball of 8 ply yarn, hot pink
One 50 g ball of 8 ply yarn, dark red
One 50 g ball of 8 ply yarn, light red
Twelve large, funky-shaped buttons

EQUIPMENT
Pair of 6 mm knitting needles (looser fabric)
Pair of 5 mm knitting needles (firmer fabric)
Scissors
Darning needle

COSY
Make two diagonal squares. Using 5 mm or 6 mm knitting needles and two strands of wool of different colours, cast on two stitches.
Row 1: Knit.
Row 2: Increase in the first and last stitch of the row.
Row 3: Knit.

Row 4: Increase in the first stitch of the row, knit to the last stitch, then increase in the last stitch.
Repeat rows 3 and 4 for at least 20 rows before making your first colour change. Then change colour, one strand at a time, as it takes your fancy. Continue increasing until you have 50 stitches on the needle or until the edge of the knitting measures well across the base of the teapot.
Next row: Knit.
Next and alternate rows: K2 tog, knit to the last two stitches, K2 tog.
Decreasing at both ends of the row will create a square. To create a rectangle for a taller teapot you will decrease at the beginning of the row while continuing to increase at the end of the row. Keep measuring the height of the rectangle against the teapot. When you have reached the right height, begin decreasing at both ends.
When you have only two stitches left on the needle, cast off.

FINISHING
Sew all the ends of the yarn into the wrong side of the work.
Join the two squares together at the bottom corners by sewing a funky-shaped button on the front and back of each corner (four buttons).
At the top of the cosy, draw up the folds to make a four-pointed star as shown in the photograph. Sew a funky-shaped button on the front and back of each of the four star points (eight buttons).

33

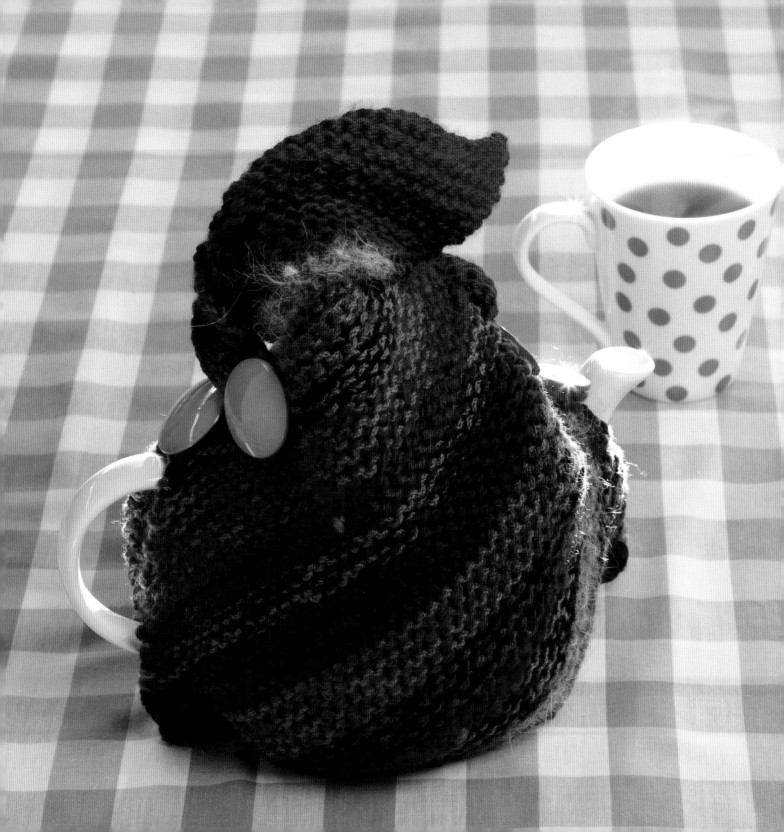

Night Cap

Knitted cosy

Night Cap is the third and last tea cosy in the diagonal knitting series and, like playing with clay or writing a novel, I asked, 'What if?' halfway through the knit design. What if I did one different thing?

SIZE
Six-cup teapot

MATERIALS
One 50 g ball of 8 ply yarn, dark blue
One 50 g ball of 8 ply yarn, light blue
One 50 g ball of 8 ply yarn, mottled blue
One 50 g ball of 8 ply yarn, purple
One 25 g ball of 8 ply yarn, red
Eight large, funky-shaped buttons

EQUIPMENT
Pair of 6 mm knitting needles (looser fabric)
Pair of 5 mm knitting needles (firmer fabric)
Scissors
Darning needle

FRONT
Using 5 mm or 6 mm knitting needles and two strands of wool of different colours, cast on two stitches.
Row 1: Knit.
Row 2: Increase in the first and last stitch of the row.
Place a marker on the side of the work that is facing you when you are on an increase (even) row. Leave this marker in place until the tea cosy is finished.
Row 3: Knit.
Row 4: Increase in the first stitch of the row, knit to the last stitch, then increase in the last stitch.
Repeat rows 3 and 4, changing the colour of one strand of yarn (as you fancy) approximately every eight rows. Continue increasing until you have 50 stitches on the needle or until the edge of the knitting measures well across the base of the teapot.
Next row: Knit.
Next and alternate rows: K2 tog, knit to the last two stitches, increase in the last stitch.
Repeat these two rows until the decrease edge of the work reaches the top of your teapot. Cast off.

BACK
The back is a mirror image of the front. Increase to 50 stitches as for the front.
Next row: Knit.
Next and alternate rows: Increase in the first stitch of the row, knit to the last two stitches, K2 tog.
Repeat these two rows until the decrease edge of the work is the same length as the front. Cast off.

FINISHING

Sew all the ends of the yarn into the wrong side of the work.

Join the two shapes together at the bottom edge by sewing a button at the front and back of each corner (four buttons).

Place the cosy on the teapot. Secure the side edges together at a point just above the spout and handle openings and sew buttons onto the front and back (four buttons). Wrap one point around the other and pin it in place. See how the knitted fabric falls from all angles. Adjust the pins if necessary. When you are happy with the twist, sew the points in place.

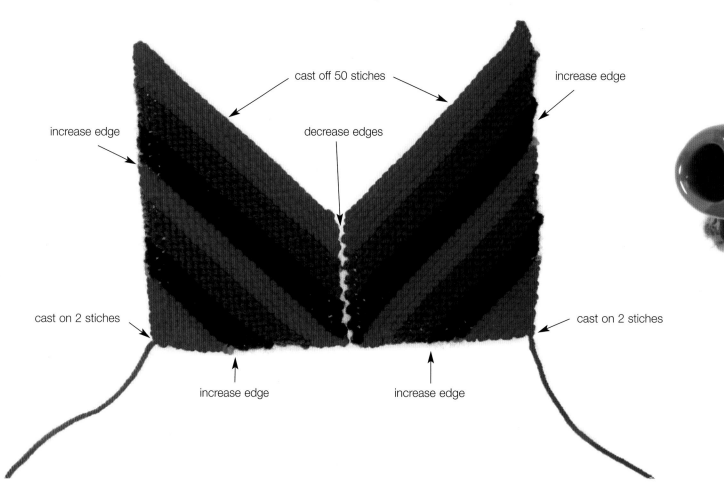

cast off 50 stiches

increase edge

decrease edges

increase edge

cast on 2 stiches

cast on 2 stiches

increase edge

increase edge

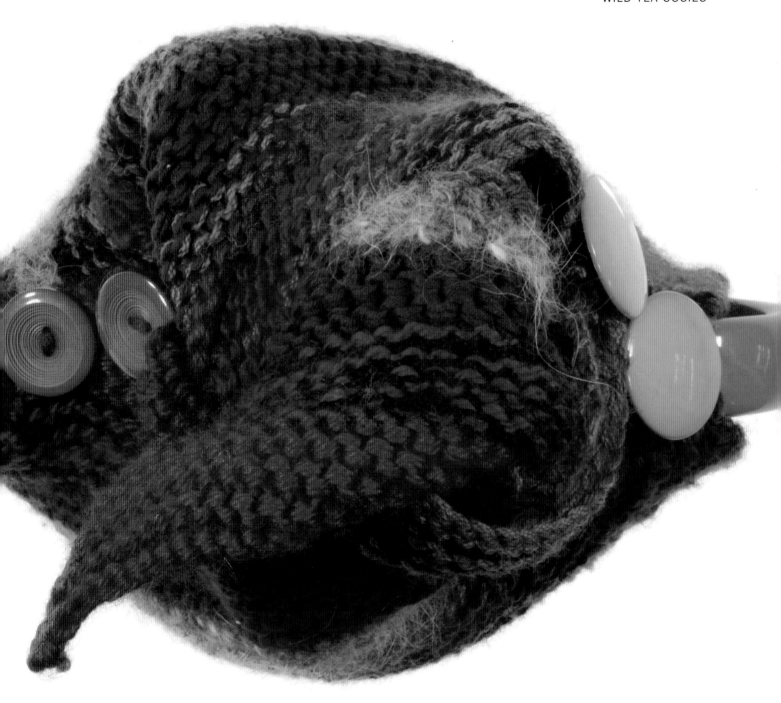

Round and round

Sculptural crochet is not an exact science. It is a bit like working with clay. All kinds of magical things happen with a simple movement this way or that. Everything matters — the wool, the size of your hook, what phase the moon is in, the colour of your eyes. And nothing matters — mistakes can turn into wondrous discoveries.

FREE-FORM DESIGN

Most of the patterns in this chapter use only chain and double crochet stitches. The instructions are deliberately vague, so that you can feel free to experiment with the design as you work. If you don't like the effect, pull it undone and work the section again. In this way you can create something truly unique.

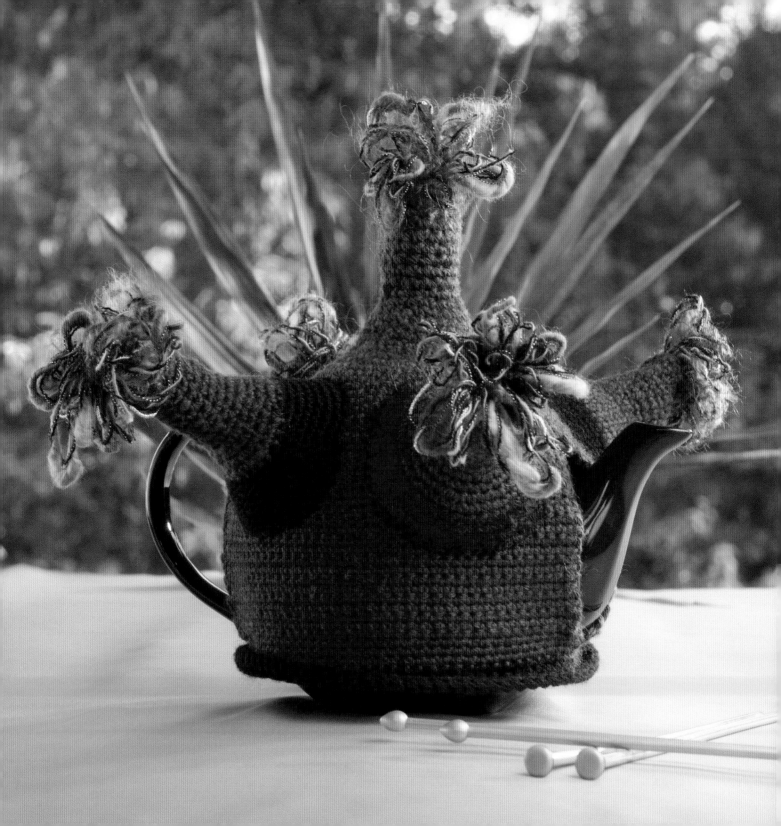

Coral Fantasy

Crocheted cosy

The colours jumped out at me from my stash. There's royal purple, iridescent purple, mottled mauve, dark dusty blue, sooty black and a sparkly slubbed fancy wool for spilling out of each of the volcanic bells.

SIZE
Six-cup teapot

MATERIALS
Two 50 g balls of 8 ply yarn, royal purple
One 50 g ball of 8 ply yarn, dark blue
One 50 g ball of 8 ply yarn, sooty black
One 50 g ball of 8 ply yarn, iridescent purple
Small amount of slubby, colourful yarn
Polyester fibre fill

EQUIPMENT
3.5 mm crochet hook
Scissors
Darning needle

BODY
Work from the top down. Using a 3.5 mm crochet hook and the royal purple yarn, make 18 chain. Use a slip stitch to join the 18 chain to form a ring. Mark the beginning of the round with a short piece of contrasting coloured thread.
Round 1: 2 ch (counts as first dc), 1 dc into each chain of the ring.
Continue to crochet straight across the beginning of the last round to form a seamless cylinder.
Rounds 2–11: 1 dc into each dc of previous round.
Change to dark blue yarn.
Round 12: *2 dc into next dc, 1 dc into next 2 dc*, repeat * to * to end (24 stitches).
Round 13 and each alternate round: 1 dc into each dc.
Round 14: *2 dc into next dc, 1 dc into next 3 dc*, repeat * to * to end (30 stitches).
Round 16: *2 dc into next dc, 1 dc into next 4 dc*, repeat * to * to end (36 stitches).
Change back to royal purple yarn.
Rounds 18–30: Continue in this increasing pattern until there are 80 stitches.

FRONT
Rows 1–22: Using 8 ply royal purple yarn, make 2 chain (counts as first dc). 1 dc into each of the next 39 dc (40 stitches). Turn and work back over the stitches you have just made. When work measures to the bottom of the teapot spout and handle, cut and tie off the end of the yarn.

BACK

Join the yarn to the top section, next to the front and work rows 1–22 as for the front. Do not break off the yarn.

BASE

Round 1: Make 2 ch as a joining bridge between the front and back sides. Continue working in the round, 1 dc into each dc.

Rounds 2–6: 1 dc into each dc. Include 1 dc into each of the chains joining the two sides of the tea cosy (84 stitches).

VOLCANIC BELLS

Make four bells, mixing and matching the yarn colours as you work. End each volcano bell with the sooty black yarn.

Using a 3.5 mm crochet hook, make 18 chain. Use a slip stitch to join the 18 chain into a ring.

Round 1: 2 ch (counts as first dc), 1 dc into each chain of the ring. Mark the beginning of the round with a short piece of contrasting coloured thread.

Rounds 2–10: Continue to crochet straight across the beginning of the last round to form a seamless cylinder. 1 dc into each dc of previous round.

Round 11: *2 dc into next dc, 1 dc into next 2 dc*, repeat * to * to end.

Round 12 and each alternate round: 1 dc into each dc.

Round 13: *2 dc into next dc, 1 dc into next 3 dc*, repeat * to * to end.

Round 15: *2 dc into next dc, 1 dc into next 4 dc*, repeat * to * to end.

Round 17: *2 dc into next dc, 1 dc into next 5 dc*, repeat * to * to end.

Slip stitch into next 2 dc for a smooth ending. Cut and tie off the end of the yarn.

PLUG

Make one circle to plug the underside of the top volcanic bell. Circles may be knitted or crocheted. Using the royal purple yarn, work a circle according to the instructions on page 107.

FINISHING

Stuff the top volcanic bell with polyester fibre fill. Sew the plug in place inside the cosy at the base of the volcano (directly above the tea pot lid).

Place the tea cosy on the teapot. Crochet has a tighter weave than knitting, so don't be afraid to give the band around the bottom of the tea cosy a good stretch to fit over the handle and spout.

Stuff the four volcano bells with polyester fibre fill and pin them to the tea cosy. Sew them in place.

Loop the slubby, coloured yarn several times around the fingers of one hand and tie it at one end. Poke the tied end down inside the volcano bell and fix it into position by sewing a number of loose threads through the volcano bell walls.

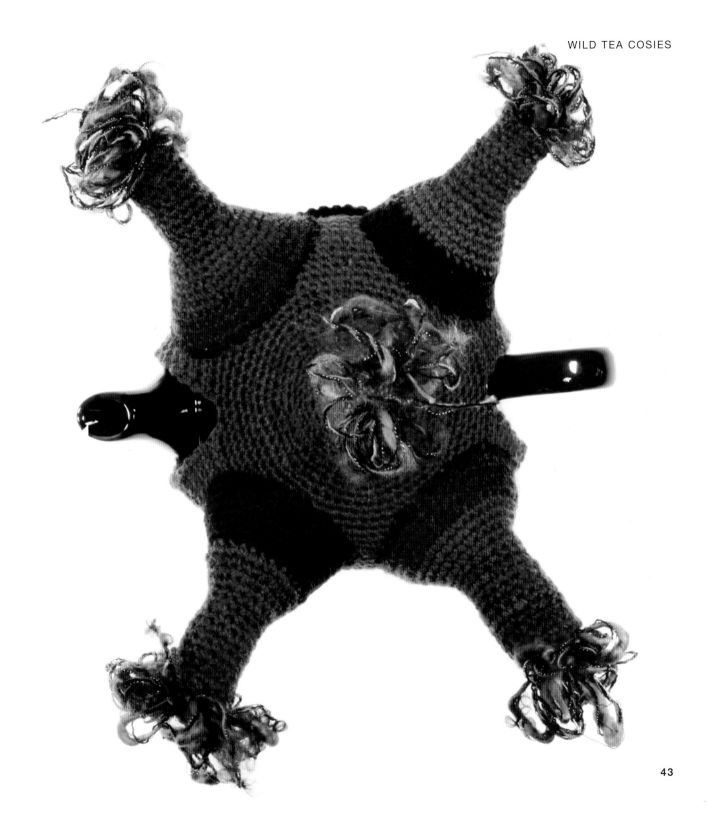

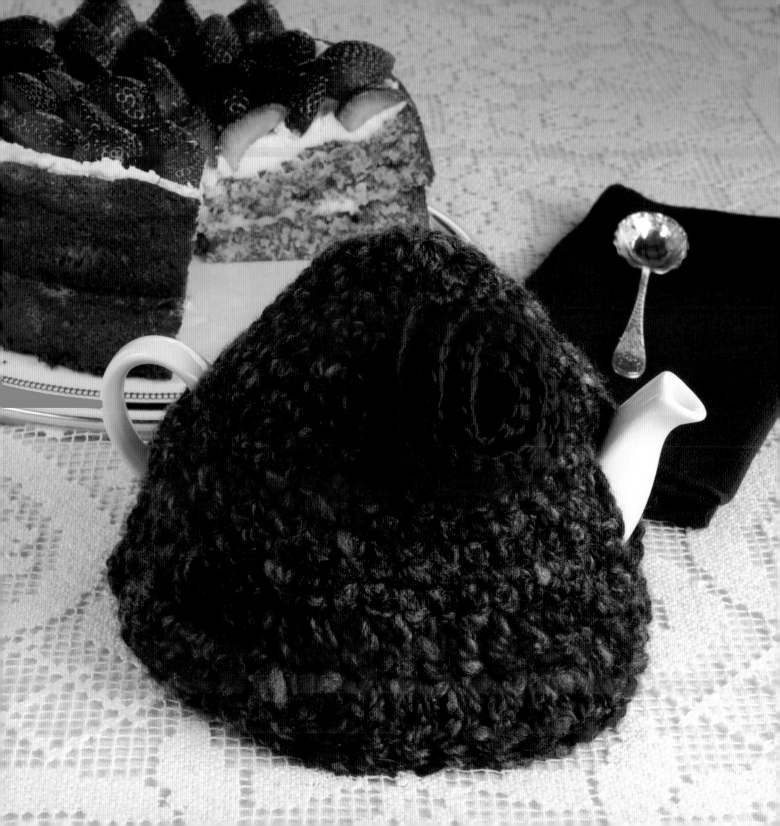

A Single Rose

Crocheted cosy

I'm giving you the sculptural instructions for this tea cosy, which means there are explanations about how to shape the cosy rather than instructions for every stitch. Master this sculpturing technique and the world is your oyster. You can do it. Go on. Be game!

SIZE
Six-cup teapot or larger

MATERIALS
Two 50 g balls of 8 ply yarn, deep red
Two 50 g balls of 8 ply yarn, dark grey-brown

EQUIPMENT
5 mm crochet hook
8 mm or 10 mm crochet hook
Scissors
Darning needle

BODY

Using a 5 mm crochet hook and two different coloured yarns, make 5 chain. Join the chain with a slip stitch to form a ring.

Round 1: 2 ch (counts as first dc), 7 dc into the ring. Mark the beginning of the round with a short piece of contrasting coloured thread.

Round 2: Continue straight across the beginning of the previous round to form a seamless circle. *2 dc into next dc, 1 dc into next dc*, repeat * to * to end.

Round 3: 1 dc into next dc, repeat to end.

Round 4: *2 dc into next dc, 1 dc into next 2 dc*, repeat * to * to end.

Round 5 and following: Continue to shape the cone by increasing stitches in each round to fit the shape of your teapot lid. Increase as evenly as possible: every third stitch or every fifth stitch, for example. The more often you increase, the flatter the curve of the cone.

Try the cone on the top of the teapot regularly. When you reach the top of the handle and spout, count the number of stitches in the last round. Divide this number by two, to give the number of stitches on each side of the tea cosy. Crochet down one side by working in rows (not rounds) on half the stitches. If your teapot has a fat, squat middle, then you might want to increase at each end of every second or third row. When you reach the underside of the handle and spout openings, cut the yarn leaving a tail to darn in.

Join the yarn to the other half of the stitches and work down the other side of the cosy in rows, increasing as for the first side if necessary.

Join the two sides of the tea cosy together by crocheting in the round again. Change to an 8 mm or 10 mm crochet hook and crochet a round of treble. Join the end of the first round to the beginning with a slip stitch. Make 3 chain (counts as 1 tr) to begin the second round. Join the end of the second round to the beginning with a slip stitch.

ROSE

Make a single red rose. Using a 5 mm crochet hook and two strands of deep red yarn, make 39 chain. The pattern is in multiples of four stitches.

Row 1: Leave the first 2 ch (counts as first dc) and make 1 htr into the third chain from the hook, 1 htr into next 2 ch, 1 dc into next ch.*1 htr into next 3 ch, 1 dc into next ch*, repeat * to * to end.

Row 2: Make 2 ch (counts as first dc) *2 tr into next 3 htr, 1 dc into next dc*, repeat * to * to end.

Row 3: 2 ch (counts as first dc) *1 dc into next 6 tr, 1 dc into dc of first row*, repeat * to * to end.

Tie off and cut the yarn, leaving a long thread at the beginning and end of the pattern. Twist the work round and round so that the petals fold outwards from the centre. Sew across the base of the rose to hold the shape.

FINISHING

Darn the ends of the yarn into the inside of the tea cosy. Place the rose at a rakish angle on the tea cosy. Pass the long threads at the base of the rose through to the wrong side of the tea cosy and tie them securely.

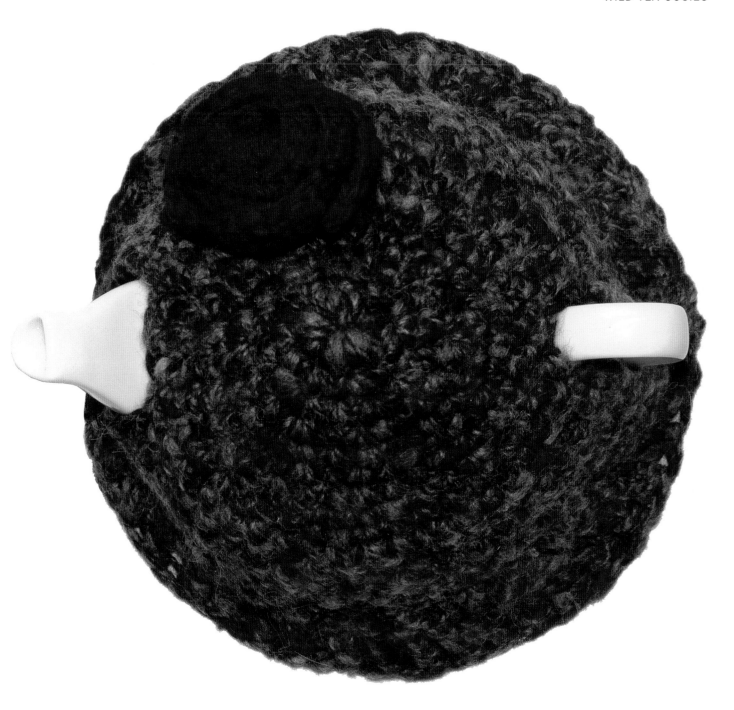

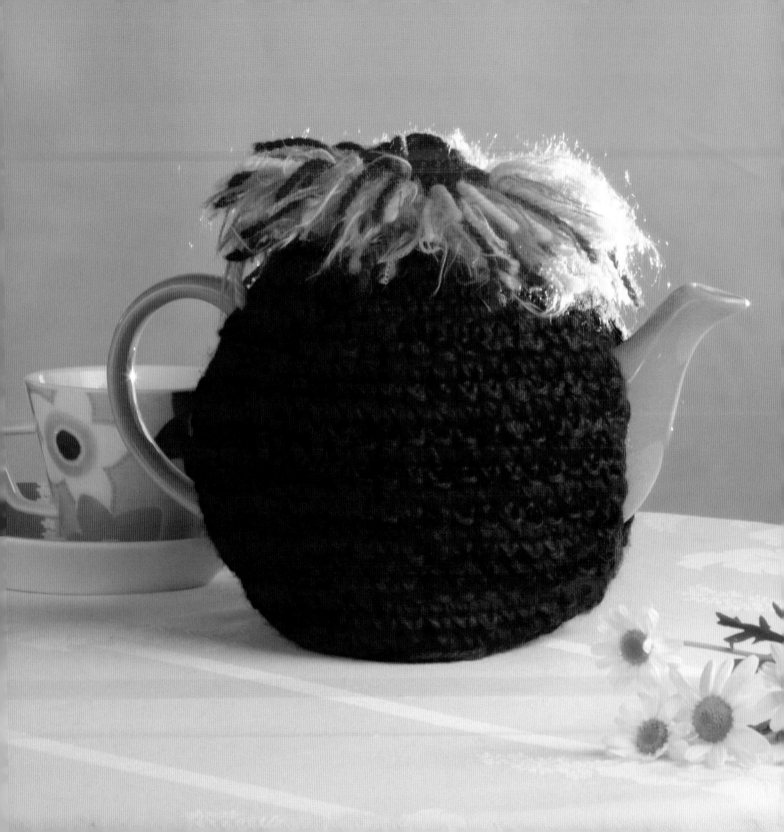

Sunflower

Crocheted cosy

Have you ever seen a sunflower turn to follow the sun across the sky? Using bright yellow yarn as an explosion of petals, this cheerful tea cosy is quick and simple to make.

SIZE
Six-cup teapot

MATERIALS
One 50 g ball of 8 ply yarn, crimson
One 50 g ball of 8 ply yarn, light red
One 50 g ball of 8 ply yarn, maroon
One 25 g ball of 8 ply yarn, canary yellow
One 25 g ball of 4 ply mohair yarn, orange

EQUIPMENT
4 mm crochet hook
5 mm crochet hook
6 mm crochet hook
Scissors
Darning needle

TOP

Work from the top down. Using a 4 mm crochet hook and one strand of crimson yarn, make 6 chain. Use a slip stitch to join the chain to form a ring.

Round 1: 12 dc into ring. Mark the beginning of the round with a short piece of contrasting coloured thread.

Continue to crochet straight across the beginning of the previous round to form a seamless circle.

Round 2: *2 dc into next dc, 1 dc into next dc*, repeat * to * to end (18 stitches).

Round 3: 1 dc into next dc, repeat to end.

Round 4: *2 dc into next dc, 1 dc into next 2 dc*, repeat * to * to end (24 stitches).

Round 5: 1 dc into next dc, repeat to end.

Change to a 5 mm crochet hook and add a strand of light red yarn. You are now working with two strands of yarn.

Round 6: *2 dc into next dc, 1 dc into next 3 dc*, repeat * to * to end (30 stitches).

Round 7: 1 dc into next dc, repeat to end.

Round 8: *2 dc into next dc, 1 dc into next 4 dc*, repeat * to * to end (36 stitches).

Round 9: 1 dc into next dc, repeat to end.

Change to a 6 mm crochet hook and add a strand of maroon yarn. You are now working with three strands of yarn.

Round 10: *2 dc into next dc, 1 dc into next 5 dc*, repeat * to * to end (42 stitches).

Round 11: 1 dc into next dc, repeat to end.

Round 12: *2 dc into next dc, 1 dc into next 6 dc*, repeat * to * to end (48 stitches).

Round 13: 1 dc into each dc. Turn your work around and work back over the stitches you have just made.

FRONT

Row 14: 1 dc into each of the next 23 dc. Turn.
Rows 15–31: 1 dc into each dc to end. Turn the work at each end of the row. Cut the yarn and tie off.

BACK

Join all three strands of yarn to the tea cosy dome, leaving one stitch between the end of the front and the beginning of the back.
Work as for the front.

BASE

Round 32: Make a three-chain bridge to join the back and front of the tea cosy. Crochet 1 dc into each dc of the lower edge of the front of the tea cosy. Make 2 or 3 chain. Continue to crochet straight across the beginning of the previous round to form a seamless circle.
Rounds 33–34: 1 dc into each dc. Include 1 dc into each of the chains joining the two sides of the tea cosy.

FINISHING

Darn the ends of the yarn into the inside of the tea cosy.
Cut the yellow, orange and light red wool into 12 cm lengths. Choose one, two or three threads at whim. Fold the lengths of thread in half and pull them through the tea cosy at the 10th round from the centre. Tie each thread off individually for security. Repeat at the 9th and 8th rounds, creating a feathery effect.

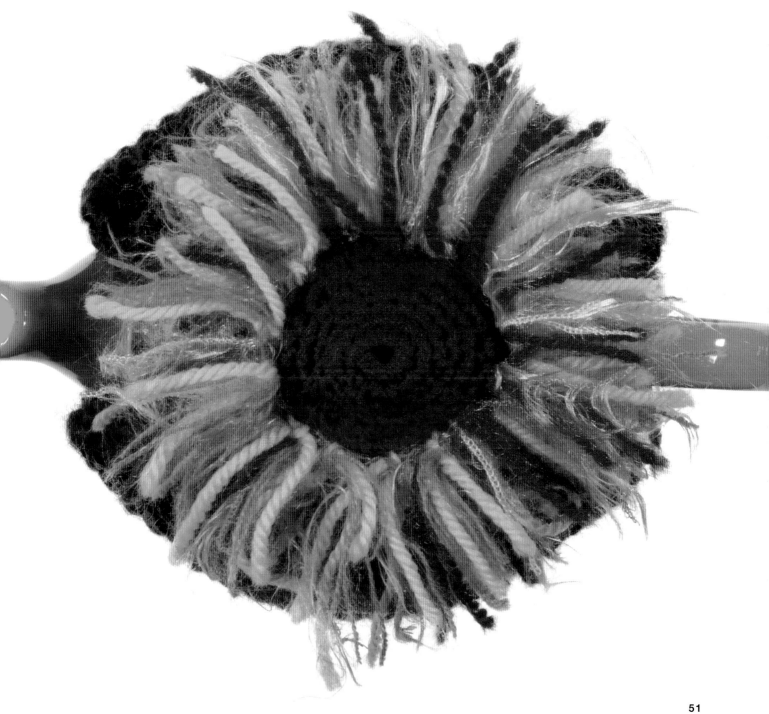

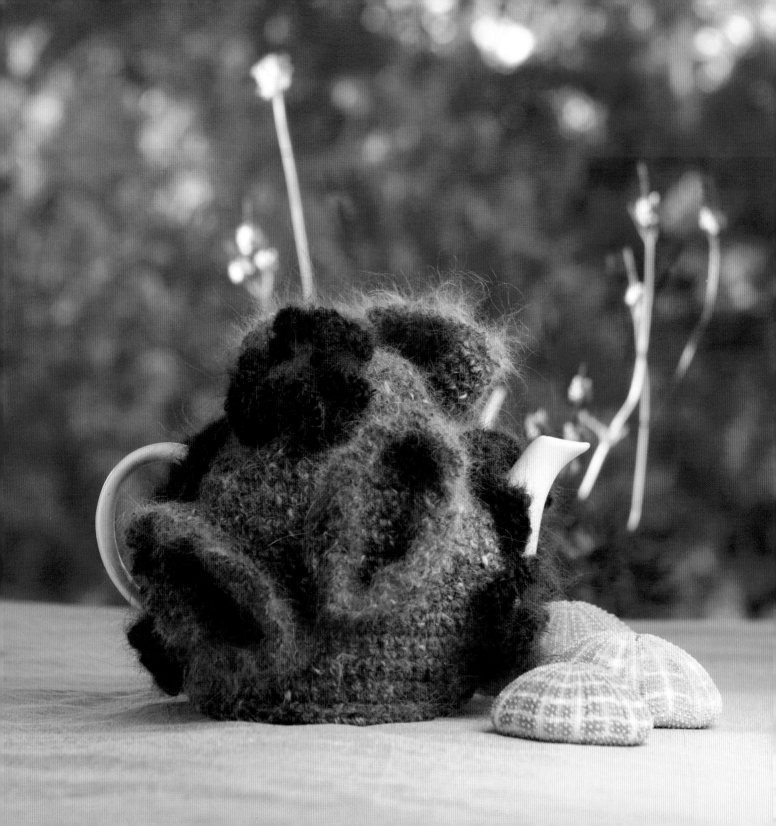

Sea Clam

Crocheted cosy

Set young people with wild imaginations to making oceans of sea creatures — a coral reef of squiggly bits and circular bits and pods and volcanic bells, they can all be found in the *Round and round* cosy projects.

SIZE
Six-cup teapot

MATERIALS
Two 100 g balls of Noro Kochoran hand-dyed yarn, blue/green
Small amount of mohair yarn in contrasting colours from your stash

EQUIPMENT
5 mm crochet hook
4 mm crochet hook
Scissors
Darning needle

BODY
Using a 5 mm crochet hook and the Noro Kochoran yarn, follow the instructions for the body of A Single Rose until the point where you are ready to join the left and right sides together under the spout and handle openings.

BASE
Join the two sides together by crocheting in the round again. Make a 3 or 4 chain bridge between the front and back sides, depending on the width of the spout and handle.
Round 1 and 2: 1 dc into next dc, repeat to end.
Round 3 and 4: *2 dc into next dc, 1 dc into next 2 dc*, repeat * to * to end.

SPOUT AND HANDLE FRILLY BITS
Using a 4 mm crochet hook and contrasting colour mohair yarn, make a slip stitch into the base of the spout opening.
Round 1: Make 2 ch (counts as first dc). Continue to dc around the whole of the spout opening.
Rounds 2 and 3: Continue to crochet straight across the beginning of the previous round to form a seamless circle. *2dc into next dc, 1dc into next 2dc*, repeat * to * to end.

SQUIGGLY BITS
Make four squiggly bits of different sizes.
Using a 5 mm crochet hook and Noro Kochoran yarn, make 25 chain. (To make a smaller cylinder, start with fewer chain.) Using a slip stitch, join the chain to make a ring.
Round 1: Make 2 ch (counts as first dc), 1 dc into each ch. Mark the beginning of the round with a contrasting coloured yarn.

Round 2: Continue to crochet straight across the beginning of the previous round to form a seamless circle. 1 dc into each dc.

Work four rounds.

Round 6: Change to a 4 mm crochet hook and one strand of fine mohair yarn. 2 dc into next dc, repeat to end of round.

CIRCULAR BITS

Make three of the same size.

Using a 5 mm crochet hook and Noro Kochoran yarn, make 5 chain. Use a slip stitch to join the chain together to form a ring.

Round 1: 1 ch (counts as first dc), 7 dc into ring, working the beginning of the yarn in as you go.

Round 2: 2 dc into each dc (14 stitches).

Round 3: 2 dc into each dc.

Round 4: *2 dc into next dc, 1 dc into next dc*, repeat * to * to end.

Change to a 4 mm crochet hook and one strand of mohair yarn.

Round 5: 2 dc into each dc.

Round 6: 2 dc into each dc.

FINISHING

With the tea cosy on the teapot, pin on the squiggly bits and circular bits. When you are happy with the arrangement, sew them into place.

Darn the ends of the yarn into the inside of the tea cosy.

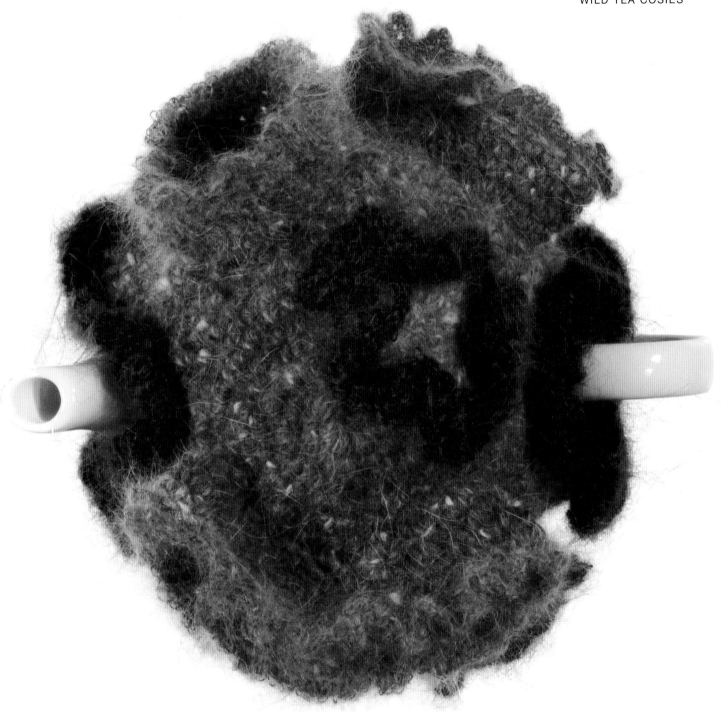

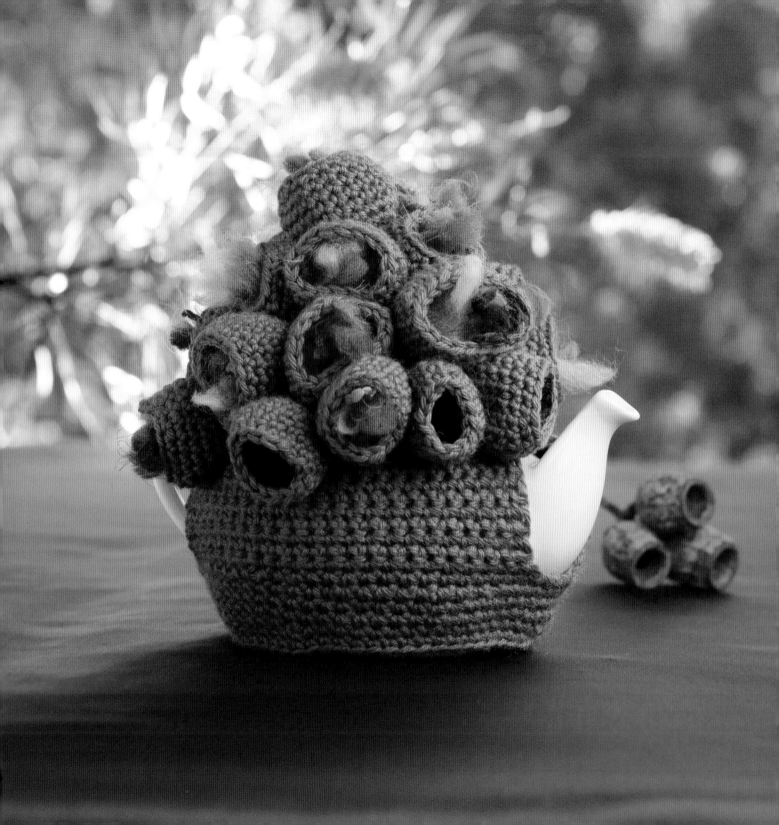

Green Eyed Monster

Crocheted cosy

Remember afternoon tea at Grandma's place? Sweet, milky tea and pink iced cupcakes; real china cups and saucers; silver spoons and linen napkins. She knew how to tame little monsters, just for a moment.

SIZE
Three-cup teapot

MATERIALS
Three 50 g balls of 8 ply Jo Sharp DK pure wool, green
Small amounts of fancy fluffy yarn, pink, white and green

EQUIPMENT
4 mm crochet hook
Scissors
Darning needle

BODY
Using a 4 mm crochet hook and the Jo Sharp DK green wool, follow the instructions for the body of A Single Rose until the point where you are ready to join the left and right sides together under the spout and handle openings.

Join the two sides together by crocheting in the round again. Make a 3 or 4 chain bridge between the front and back sides, depending on the width of the spout and handle. Three or 4 chain stitches will also accommodate a squat teapot. Continue crocheting in the round for 3 or 4 rounds.

PODS
Make a lot of pods: at least 28.
Make 5 chain. Using a slip stitch, join the chain to make a ring.
Round 1: 1 ch (counts as first dc), 7 dc into ring. Mark the beginning of the round with a contrasting coloured yarn.
Round 2: Continue to crochet straight across the beginning of the previous round to form a seamless circle. *2 dc into next dc, 1 dc into next dc*, repeat * to * to end.
Round 3: *2 dc into next dc, 1dc into next 2 dc*, repeat * to * to end.
Round 4: *2 dc into next dc, 1 dc into next 3 dc*, repeat * to * to end.
Rounds 5–9: 1 dc into each dc.
Round 10: *Miss 1 dc, 1 dc into next 3 dc*, repeat * to * to end.

Slip stitch into next 2 dc for a smooth finish. Tie off thread and darn into the side of the pod right down to the base. Leave a long tail at the beginning and end of the yarn for attaching the pod to the cosy.

LINING

Make a circular piece of lining to cover threads on the underside of the body. Circles may be knitted or crocheted. Using Jo Sharp DK yarn, work a circle according to the instructions on page 107.

FINISHING

Sew little tufts of fancy, fluffy yarn inside the pods. Working from the centre top of the tea cosy body down, place the pods on the top of the cosy. Pull the pod threads through to the inside of the tea cosy and tie them off. Test how the cosy sits on the teapot regularly as you work.
Sew the lining to the underside of the tea cosy top to cover all the loose thread ends.

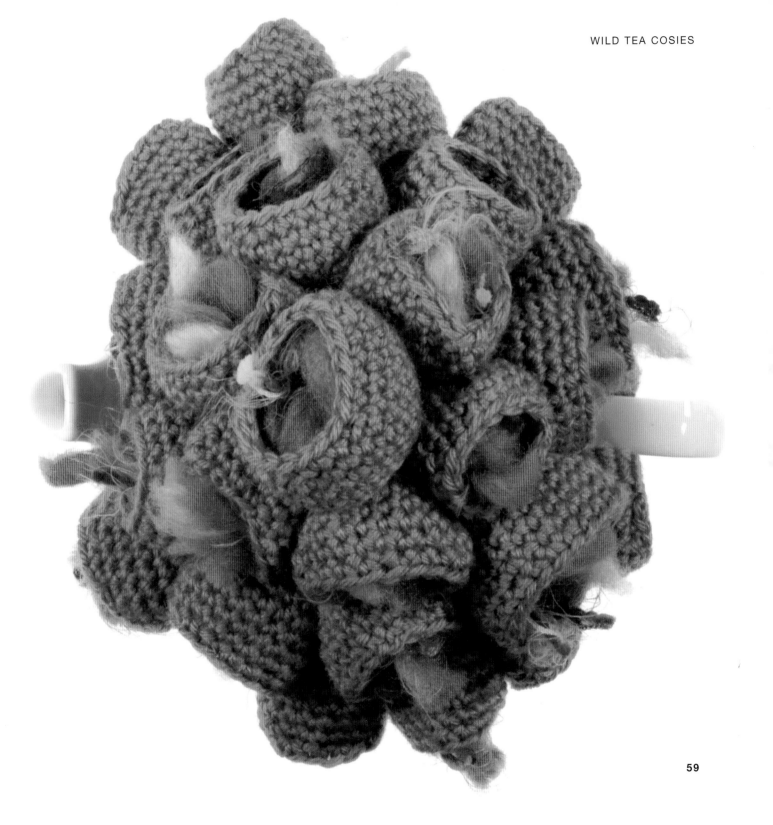

Simply magic

What a difference a decoration makes. These simple knitted tea cosies get all their character from the embellishments that are added to the basic shape.

CHOOSING COLOURS

Colours can make you love or hate a thing. Choosing the colours is a favourite part of starting something new. Be adventurous. Sometimes a great design can happen by accident, like running out of a colour.

TWO STRANDS

Use two or even three strands of 8 ply yarn. There are two practical reasons for this: a thicker fabric will keep the tea piping hot and provide support to the structure of the tea cosy. There is also an artistic reason: two strands of wool give double the opportunity for going wild with colour.

NEEDLE SIZE

The standard needle size for 8 ply yarn is 4 mm. If you only have 5 mm needles, knit up a little square. If it's too loose it will fall about all floppy. If it's too tight you'll get a stiff straw basket. Or go shopping. You can never have enough knitting needles.

YARN ENDS

Leave a long thread when starting and ending yarns (and changing colours) so that you can thread a darning needle and sew the ends into the wrong side. Weave the yarn through the back of the knitted loops of the same colour.

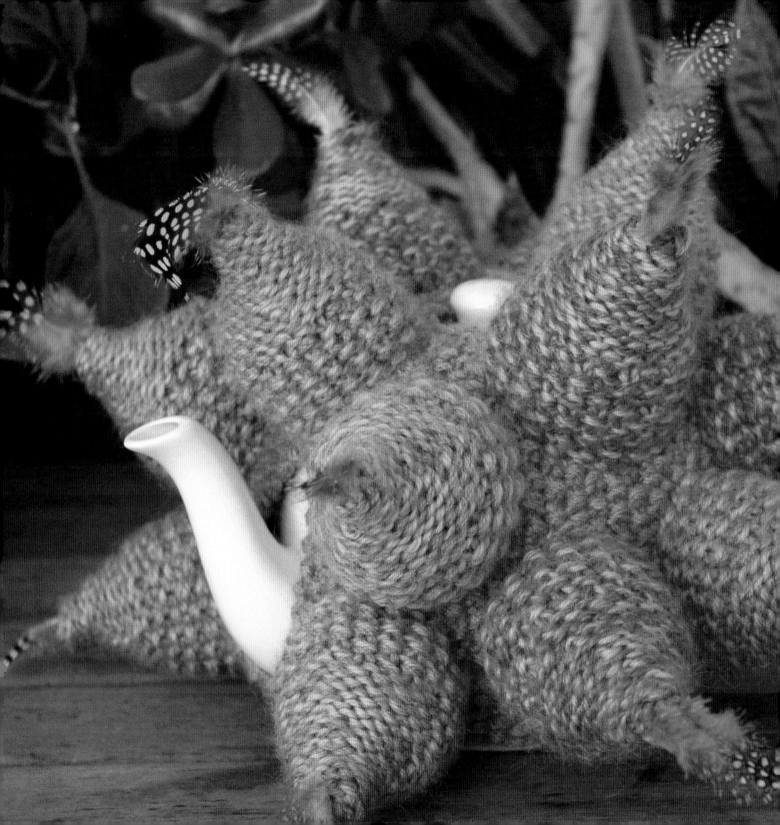

Sea Squirt

Knitted body and bits

There is a lot of knitting in this tea cosy, but what a result! You could make it for a smaller teapot but somehow I think it would lose a little of its magnificence. Afternoon tea on the verandah will never be quite the same again.

SIZE

Eight-cup teapot

MATERIALS

Six 50 g balls of 8 ply yarn, dusty green
Six 50 g balls of 8 ply yarn, mustard yellow
Six 50 g balls of 4 ply mohair yarn,
terracotta orange
Polyester fibre fill
Sixteen small feathers
Cotton sewing thread

EQUIPMENT

Pair of 6 mm knitting needles
Four 6 mm double-pointed needles
Scissors
Darning needle

BODY

Make two pieces, front and back.
Using 6 mm knitting needles and one strand each of the green, yellow and orange yarn, cast on 35 stitches.

MOSS STITCH

It is important to have an odd number of stitches on your needle to produce moss stitch. It's not a difficult stitch: you simply knit the purl stitches and purl the knit stitches.
Row 1: *K1, P1*, repeat * to * to last stitch, knit 1.
Row 2: *K1, P1*, repeat * to * to last stitch, knit 1.
Continue for 30 rows or until the side edges measure 3 cm above the spout and handle of the teapot.
While decreasing to shape the top of the cosy you will not be able to keep exactly to the moss stitch pattern. In some rows, two purl stitches will sit side by side and two knit stitches will sit side by side. This won't be noticeable, as most of the base fabric will be covered with the sea squirt cones.
Row 31: *P2 tog, moss stitch 3 st, K2 tog, moss stitch 3 st*, repeat * to * to end (28 stitches).
Row 32: Moss stitch.
Row 33: Moss stitch.
Row 34: Moss stitch 3 st, *P2 tog, moss stitch 2 st, K2 tog, moss stitch 2 st*, repeat * to * to last 3 st, moss stitch (22 stitches).
Note: You should now have K1, P1, K1, P1 along the entire row. It doesn't really matter if you don't.
Row 35: Moss stitch.
Row 36: Moss stitch.
Row 37: *K2 tog, moss stitch 3 st, P2 tog, moss stitch 3 st*, repeat * to * to end (18 stitches).
Row 38: Moss stitch.
Row 39: Moss stitch.

Row 40: *K2 tog, moss stitch 2 st, P2 tog, moss stitch 2 st*, repeat * to * to last 3 st, moss stitch (13 stitches).

Row 41: Moss stitch, knitting all purl stitches and purling all knit stitches.

Row 42: Moss stitch.

Cast off.

SEA SQUIRT CONE

Make 16 cones. Using 6 mm double-pointed needles and one strand each of the green, yellow and orange thread, cast on 21 stitches — 7, 7, 7 stitches on each needle.

Round 1: K1, P1, K1, P1 to end.

Round 2: P1, K1, P1, K1 to end.

Continue in moss stitch for nine rounds.

Round 10 and each alternate row: Knit.

Round 11: *K5, K2 tog*, repeat * to * to end.

Round 13: *K4, K2 tog*, repeat * to * to end.

Round 15: *K3, K2 tog*, repeat * to * to end.

Round 17: *K2, K2 tog*, repeat * to * to end.

Round 19: *K1, K2 tog*, repeat * to * to end.

Round 21: K2 tog onto the one needle (3 stitches).

Cut the yarn, leaving enough to thread into a darning needle. Pick up the last three stitches with the darning needle and secure with two or three overstitches.

Turn the cone inside out so that the wrong side of the stocking stitch becomes the right side of the fabric. Stuff firmly with polyester fibre fill.

FINISHING

Darn in all the loose yarn ends into the back of the tea cosy fabric. Sew the front and back together, leaving openings to fit the spout and handle of your teapot.

There is no need to darn in the loose ends inside the sea squirt cones. These threads can simply be hidden inside with the stuffing.

Place the tea cosy over your teapot. Pin seven sea squirt cones to the front of the cosy and seven to the back. Try not to line them up too evenly. Pin two sea squirt cones to the top of the cosy, one above the handle opening and one above the spout opening. Move them around until you are happy with the effect.

Now that you know what it will look like, unpin all the sea squirt cones and use the yellow yarn to sew them on, one by one. Regularly put the tea cosy on the teapot to make sure the cones are sitting well.

For the finishing touch, spear the shafts of the feathers into the end of each of the cones and secure with a couple of stitches in cotton sewing thread.

WARNING

Beware the cat!
Cats love feathers.

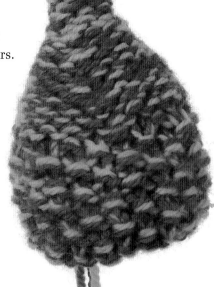

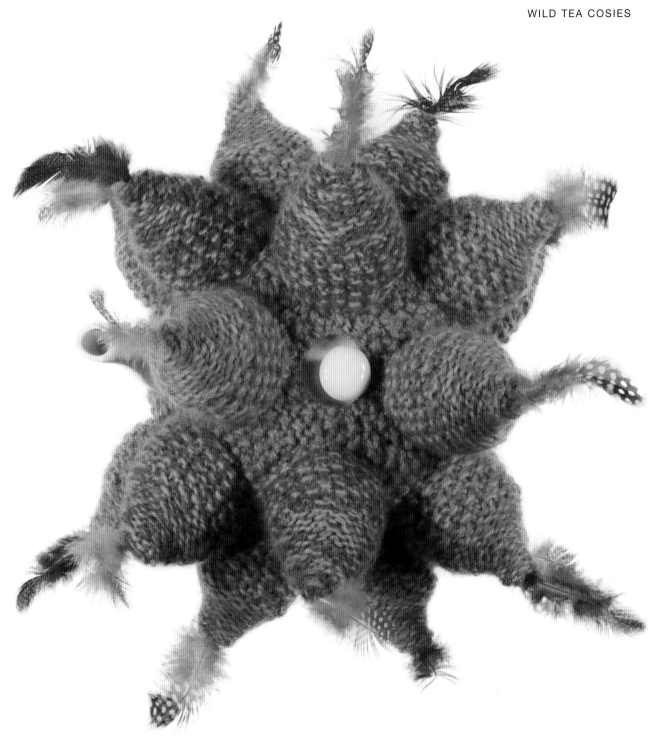

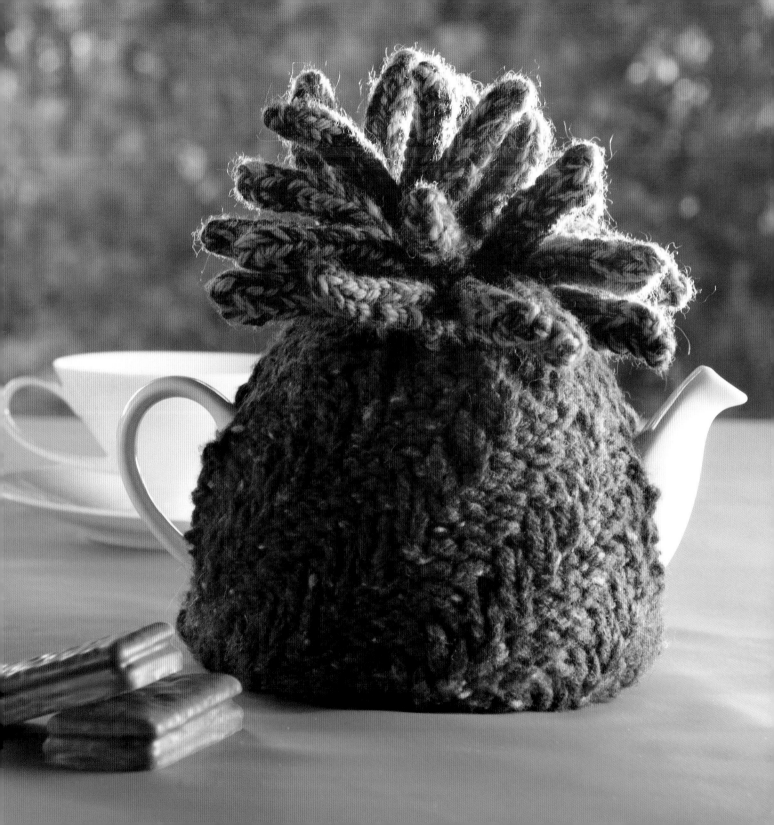

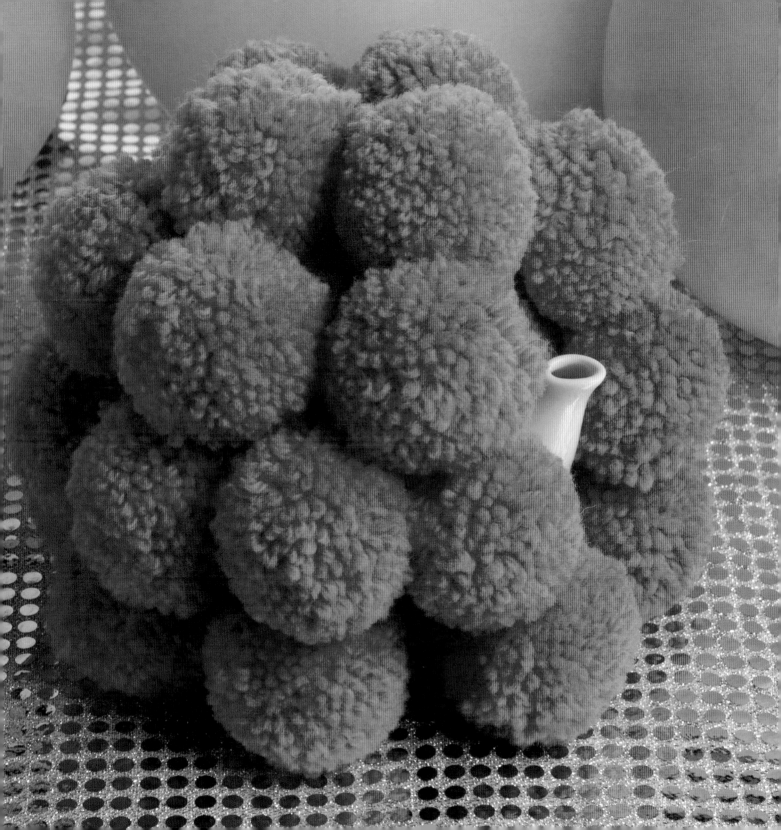

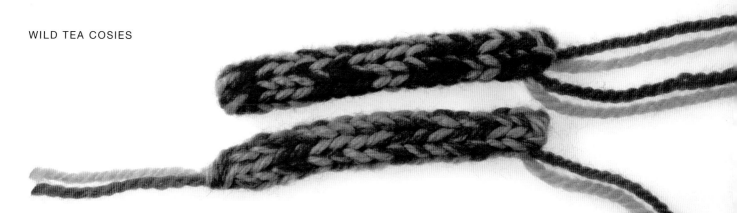

Continue in this pattern until the work reaches 3 cm above the spout and handle of the teapot.
To decrease, change to 4 mm knitting needles and one strand of yarn. Tie off the second strand, leaving a tail for darning.
Decreasing row 1: *K3, K2 tog*, repeat * to * to end.
Row 2 and each alternate row: Purl.
Decreasing row 3: *K2, K2 tog*, repeat * to * to end.
Decreasing row 5: *K1, K2 tog*, repeat * to * to end.
Break off the yarn and thread it through the remaining eight stitches. Draw the yarn up tight and tie it off.

CACTUS FLOWER

Make at least 24 I-cords using both pink yarns together (two strands).
Using 5 mm double-pointed needles and two strands of 8 ply yarn, cast on four stitches. Slide the four stitches to the other end of the needle, draw the yarn across the back of the knitting, left to right, and knit the four stitches again. Keep the knit side of the fabric towards you for every row. Repeat this instruction 12 times or until you have the length of I-cord you want.

To finish, thread the yarn through the four stitches and draw them up tightly. Darn to secure.
Thread a crochet hook through the I-cord, from one end to the other, and pull the end of the yarn down the middle of the cord. Leave the tail long, as you will use it to secure the I-cord to the tea cosy.

LID LINING

Make one circle to line the underside of the cosy top and hide the ends of the I-cord yarns. Circles may be knitted or crocheted. Using the tweed yarn, work a circle according to the instructions on page 107.

FINISHING

Sew up the sides of the tea cosy, leaving openings for the spout and handle of your teapot. Secure the I-cords to the top of the tea cosy by pulling the yarn ends through and tying them securely inside the cosy.
Place the tea cosy on the teapot. The cactus flowers may droop a little. If you prefer them to stand up more, sew them together close to their bases with pink yarn. Sew the lid lining into the underside of the cosy to hide all the yarn ends.

Cactus Delight

Knitted body and flowers

Change the colour of your wool and Cactus Delight might go by any number of aliases. An orange body with green I-cords at the crown might be dubbed 'Pineapple Delight'.

SIZE
Two-cup teapot

MATERIAL
Two 50 g balls of Jo Sharp Silkroad Aran Tweed, ivy, or 8 ply tweed yarn, dark green
One 50 g ball of 8 ply yarn, hot pink
One 50 g ball of 8 ply yarn, lolly pink

EQUIPMENT
Pair of 6 mm knitting needles
Pair of 4 mm knitting needles
Two 5 mm double-pointed needles
4 mm crochet hook or smaller
Scissors
Darning needle

BODY
This is a little tea cosy, so you can knit both the front and back at the same time. Find the beginning and the end of the same ball of tweed yarn and work with both strands for the front. Do the same with the remaining ball of tweed yarn for the back. The 6 mm knitting needles will hold all of the stitches for both sides of the cosy.

Cast on 20 stitches, using two strands from one ball of yarn. Do the same with the other ball of yarn.

If you want to adjust the pattern to fit a bigger teapot, remember that the number of cast on stitches should be a multiple of five to accommodate the shifting ribbed pattern.

SHIFTING RIBBED PATTERN
Work both front and back of the tea cosy at the same time.

Row 1: *P3, K2*, repeat * to * to end.

Row 2 and each alternate row: Knit the knit stitches and purl the purl stitches.

Row 3: P2, K2, *P3, K2*, repeat * to * to last stitch, P1.

Row 5: P1, K2, *P3, K2*, repeat * to * to last two stitches, P2.

Row 7: K2, *P3, K2*, repeat * to * to last three stitches, P3.

Row 9: K1, *P3, K2*, repeat * to * to last four stitches, P3, K1.

Row 11: *P3, K2*, repeat * to * to end.

Party Girl

Knitted cosy
Pompoms

I have to admit to deliberately choosing a small teapot for Party Girl. It took 25 pompoms and three evenings sitting in front of the television to dress her. I thought about using child labour … but he already grew up and left home.

SIZE
Three-cup teapot

MATERIALS
Five 50 g balls of 8 ply yarn, pink

EQUIPMENT
Pair of 4 mm knitting needles
Cardboard
Scissors
Darning needle

BODY
Using 4 mm knitting needles and one strand of yarn, cast on 35 stitches for the front. Repeat with a second ball of yarn to make the back at the same time. Knit every row until the sides measure to just above the spout and handle.
Decrease row 1: *K5, K2 tog*, repeat * to * to end.
Next and alternate rows: Knit.
Decrease row 3: *K4, K2 tog*, repeat * to * to end.
Decrease row 5: *K3, K2 tog*, repeat * to * to end.
Decrease row 7: *K2, K2 tog*, repeat * to * to end.
Decrease row 9: *K1, K2 tog*, repeat * to * to end.
Thread the yarn through the remaining 10 stitches, draw up tightly and darn to secure.

POMPOMS
Make approximately 25 pompoms.
Cut two cardboard circles, 5 cm in diameter. Make a hole in the centre of each, 2 cm in diameter.
Put the two circles together and use a darning needle to wind the yarn around the cardboard through the hole in the centre. Keep going until there is very little room left in the centre.
Slide the blade of the scissors between the two cardboard circles at the outer edge and cut the yarn all the way around.
Wrap a strand of yarn between the two cardboard circles twice, pull it tight and make a secure knot. Slide the cardboard circles off the pompom and fluff it up to a nice round ball. Leave the ends of the tie yarn long to secure the pompom to the tea cosy.

FINISHING
Sew the front and back of the tea cosy together from the centre top down to the top of the spout and handle openings. Sew the side seams together underneath the spout and handle openings.
Use a crochet hook to pull the long tie yarns of the pompoms through the knitted cosy and tie the yarn in secure knots on the inside of the cosy.

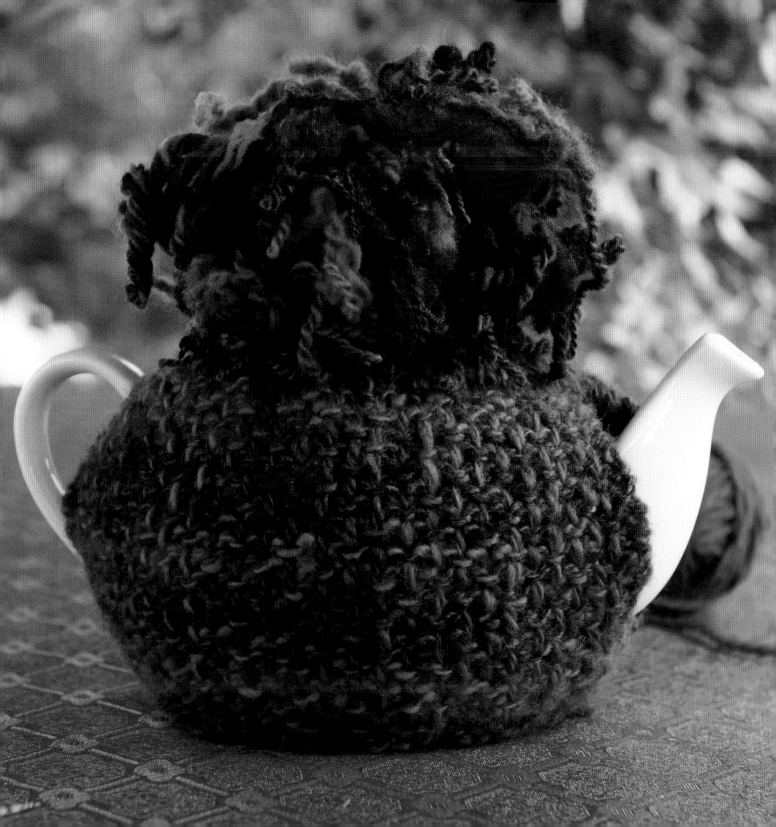

wonder weave

Knitted cosy
Pompoms

This tea cosy is not woven at all. It is knitted in the simplest of stitches: garter stitch. The woven effect comes from threading a strand of yarn through the knitted stitches to create an illusion of woven fabric. You get the best effect using variegated wool.

SIZE
Two-cup teapot

MATERIALS
Two 50 g balls of 5 ply variegated yarn, green, blue and red tones

EQUIPMENT
Pair of 4 mm knitting needles
Scissors
Darning needle

BODY
Using 4 mm knitting needles, cast on 30 stitches. Using the second ball of wool, cast on another 30 stitches so that you can knit the front and back of the tea cosy at the same time. To make a larger tea cosy, simply add more stitches when you cast on.
Row 1: Knit.
Row 2: Knit.
Continue knitting in garter stitch for 35 rows or until the sides of the work measure to 2 cm above the spout and handle.
Row 36: Purl.
Row 37: Knit.
Repeat rows 36 and 37 (stocking stitch) for 15 rows. Cast off.

WEAVING
With a darning needle threaded with one strand of the variegated yarn, secure the yarn to the inside of the tea cosy at one side. Bring the thread to the front and begin the weaving.
Working from the bottom up, pass the yarn under the loop of the knitted stitch from every second row. Use the 'u' stitches and ignore all the 'n' stitches. When you reach the top of the garter stitch section, weave the yarn back down the next column of 'u' stitches in alternate rows to the previous line of weaving.
At the end of each row of weaving, adjust the yarn to match the tension of the garter stitch.

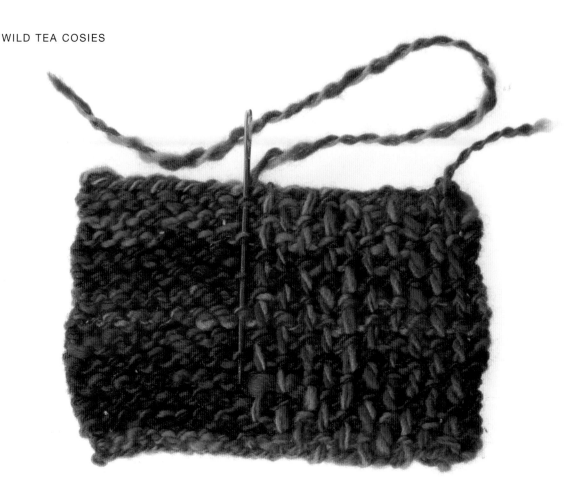

POMPOMS

Accidental pompom

I call it the 'accidental pompom' because it made itself. The wool is my own home-spun wool: two spools of wool plied together form a workable yarn. The 'accidental pompom' is what I picked up off the floor after unravelling the leftover wool from one spool. I've since learnt to ply from one spool — Navaho plying — so there won't be any more accidental pompoms for me.

Not too regular pompom

You might like to make a regular pompom — but not too regular. Try making it very large. Add odd strands of sparkly fancy wool, slubbed wool or even a feather or three. Party Girl (see page 71) has instructions for making pompoms.

FINISHING

Sew the front and back of the cosy together, leaving openings for the teapot spout and handle. Darn a thread through the top of the tea cosy. Pull it tight and tie it off. Attach the pompom. There is no need to darn in the ends of the darning threads as they will become part of the pompom.

Lofty lovelies

These exalted tea cosies will stand proud over a standard six- or eight-cup teapot. Their extra height is not the only attraction: well-chosen embellishments set a funny or funky tone.

DECREASING

If you need to adjust the stitch numbers to accommodate your special teapot, and you have cast on fewer than 60 stitches, try to work in multiples of six stitches. In each row, you will decrease six times as follows:

- 60 stitches divided by six = 10. In this round, there are 10 stitches to each section; that is, eight stitches to knit and two to knit together (decrease).
- 54 stitches divided by six = nine. In this round, there are nine stitches to each section; that is, seven stitches to knit and two to knit together (decrease).
- 48 stitches divided by six = eight. In this round, there are eight stitches to each section; that is, six stitches to knit and two to knit together (decrease).

Remember, the more rounds you knit between decreasing rounds, the higher your tower will stand.

KNITTER'S CROCHET HOOK

Every knitter should own at least one crochet hook. It is a great tool for drawing yarn through knitted fabric, making fringes and picking up dropped stitches.

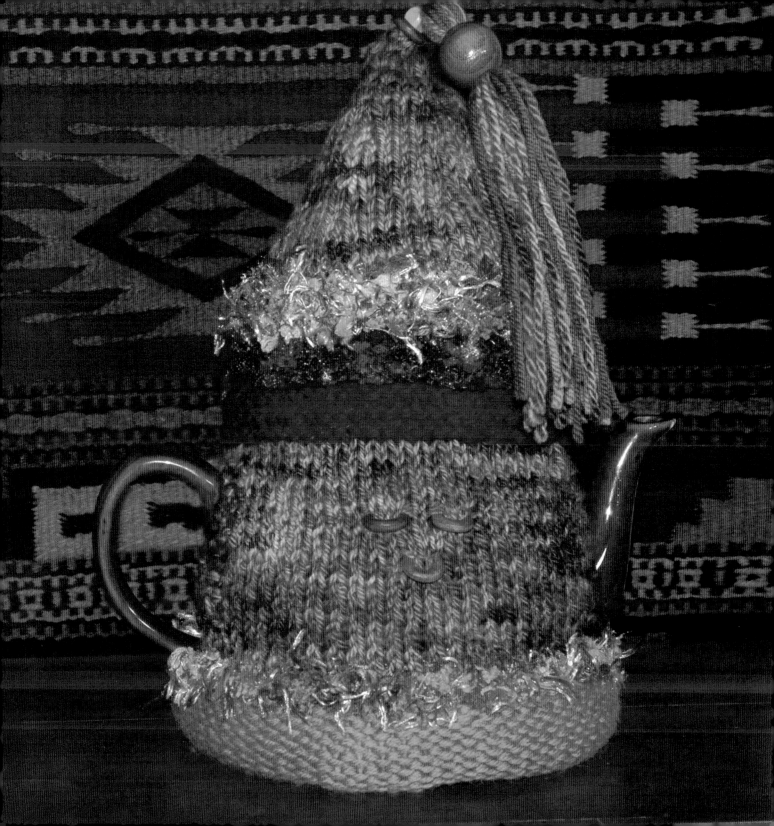

Turkish Delight

Knitted cosy

This tower of a tea cosy might easily cover a Russian samovar or Turkish coffee pot, turning your ordinary teapot into an exotic table accessory. My intention was to make something wild and African but instead it turned out exotic and Middle Eastern. Fabulous things happen by accident, as much as by design.

SIZE
Six-cup teapot

MATERIALS
Three 50 g balls of 10 ply variegated yarn, gold tones
One 25 g ball of 8 ply yarn, mustard
One 25 g ball of 8 ply yarn, tangerine
One 50 g ball of 8 ply variegated yarn, purple and orange tones: main colour
One 25 g ball of shaggy textured yarn, gold and brown tones
Selection of wooden beads
Polyester fibre fill

EQUIPMENT
Five 5 mm double-pointed needles
Scissors
Darning needle

BASE
Using 5 mm double-pointed needles and two strands of 8 ply mustard yarn, cast on 60 stitches — 15, 15, 15, 15 stitches on each needle. Join the stitches in a round, making sure that the stitches are not twisted around the needles.
Rounds 1–16: Knit. Knitting in the round creates a stocking stitch fabric, which will roll up beautifully.
Rounds 17 and 18: Change to a shaggy textured yarn. Using one strand, purl these two rounds. Purling helps to bring the best of the shaggy fibres to the front of the work.

FRONT
Change to 10 ply gold variegated yarn.
Row 19: Have the right side of the work facing you. Using one strand, knit the next 30 stitches. Turn.
Row 20: With the wrong side of the work facing you, K3, purl to last 3 st, K3.
Repeat these two rows of stocking stitch eight times or until the work measures to the top of your teapot spout and handle. Cut the yarn and tie it off.

BACK
Work on the remaining stitches as for the front.

TOWER
Important! Read this section of the pattern right through before beginning to knit the tower.

Change to tangerine yarn and begin to knit in rounds again, joining the front and back sections as you go. Work six rounds of garter stitch (knit one round, purl one round).

Change to purple and orange variegated yarn and begin the decreasing as follows:

Decreasing round 1: *K8, K2 tog*, repeat * to * to end.

Work three rounds of garter stitch.

Decreasing round 2: *K7, K2 tog*, repeat * to * to end.

Work one round of purl to maintain the garter stitch fabric, and change to a shaggy textured yarn.

Work two rounds of garter stitch.

Decreasing round 3: *K6, K2 tog*, repeat * to * to end.

Work three rounds of garter stitch. Change to main colour yarn and stocking stitch (knit every round).

Decreasing round 4: *K5, K2 tog*, repeat * to * to end.

Work three rounds of stocking stitch.

Decreasing round 5: *K4, K2 tog*, repeat * to * to end.

Work three rounds of stocking stitch.

Decreasing round 6: *K3, K2 tog*, repeat * to * to end.

Work three rounds of stocking stitch.

Decreasing round 7: *K2, K2 tog*, repeat * to * to end.

Work three rounds of stocking stitch.

Decreasing round 8: *K1, K2 tog*, repeat * to * to end (10 stitches).

Cast off.

Remember! Change yarns every six rounds and decrease every four rounds. Work contrasting yarns in garter stitch. Work the main colour in stocking stitch.

TOWER FLOOR

Make one circle to hold the stuffing in the tower section. Circles may be knitted or crocheted. Using the main colour yarn, work a circle according to the instructions on page 107.

FINISHING

The stocking stitch base will roll up nicely. You can leave it rolled, or stitch the edge to the top row of stocking stitch and stuff it with polyester fibre fill.

Stuff the tower with polyester fibre fill and sew in the tower floor to hold the stuffing in place.

Add a tassel. Cut lengths of the leftover yarn, double the length you want the tassel to be. Tie a piece of yarn halfway along the lengths, then pull the tied section through a large wooden bead. Pass the tied yarn through some more beads if you wish and fasten it to the top of the cosy.

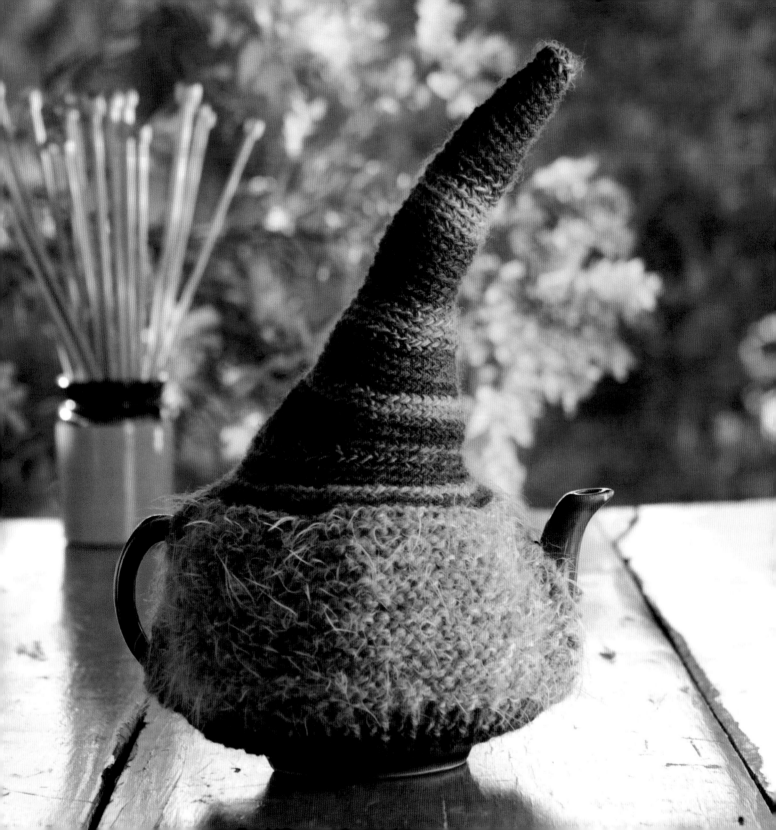

Eddie Emu

Crocheted and knitted cosy

He doesn't look exactly like an emu but he has the essence of one. If he had a bill he might be a duck, or if he had some feathers popping out the top he might be a rooster. But he doesn't have any of these things, so let me introduce Eddie Emu, at home amongst the spinifex and mulgas.

SIZE
Six-cup teapot

MATERIALS
One 50 g ball of 10 ply variegated yarn, green and brown tones
One 50 g ball of 12 ply feathery textured yarn, beige and brown tones
Polyester fibre fill

EQUIPMENT
4 mm crochet hook
Pair of 6 mm knitting needles
Pair of 4 mm knitting needles (optional)
Scissors
Darning needle

BODY

This cosy is worked from the tip to the base. Using a 4 mm crochet hook and 10 ply green and brown variegated yarn, make 4 chain. Use a slip stitch to join the chain to form a ring.

Important! Work into the back of the loop for all crochet stitches. This technique gives a tighter weave and a ribbed effect.

Round 1: 8 dc into ring.

Mark the beginning of the round with a small thread of contrasting colour.

Round 2: 1 dc into each dc to end.

Round 3: *2 dc into next dc, 1 dc into next dc*, repeat * to * to end (12 stitches).

Next three rounds: 1 dc into next dc to end.

Round 7: *2 dc into next dc, 1 dc into next 2 dc*, repeat * to * to end (16 stitches).

Next five rounds: 1 dc into next dc to end.

Round 13: *2 dc into next dc, 1 dc into next 3 dc*, repeat * to * to end (20 stitches).

Next seven rounds: 1 dc into next dc to end.

Round 21: *2 dc into next dc, 1 dc into next 4 dc*, repeat * to * to end (24 stitches).

Next and every alternate round: 1 dc into next dc to end.

Round 23: *2 dc into next dc, 1 dc into next 5 dc*, repeat * to * to end (28 stitches).

Round 25: *2 dc into next dc, 1 dc into next 6 dc*, repeat * to * to end (32 stitches).

Round 27: *2 dc into next dc, 1 dc into next 7 dc*, repeat * to * to end (36 stitches).

Round 29: *2 dc into next dc, 1 dc into next 8 dc*, repeat * to * to end (40 stitches).
Round 30: 1 dc into next dc to end.

The following part of the pattern helps give the cone its wonky lean.
Round 31: 1 htr into next 4 dc, 1 tr into next 4 dc, 1 dtr into next 4 dc, 1 tr into next 4 dc, 1 htr into next 4 dc, 1 dc into next dc to end of round.
Round 32: *2 dc into next st, 1 dc into next 5 st*, repeat * to * to last four stitches, 1 dc into next st to end (46 stitches).
Round 33: 1 htr into next 5 st, 1 tr into next 5 st, 1 dtr into next 5 st, 1 tr into next 5 st, 1 htr into next 5 st, 1 dc into next st to end of round.
Round 34: *2 dc into next st, 1 dc into next 6 st*, repeat * to * to last four stitches, 1 dc into next st to end (52 stitches).
Round 35: 1 dc into next dc to end.
Round 36: *2 dc into next dc, 1 dc into next 3 dc*, repeat * to * to end (65 stitches).
Round 37: 1 dc into next dc to end.
Round 38: *2 dc into next dc, 1 dc into next 4 dc*, repeat * to * to end (78 stitches).
Slip stitch into next 2 dc to make a smooth finish to the round. Cut and tie off yarn.

BODY FRONT

Find the point on the last round of the cone from where you can trace a line up through the middle of the double treble stitches. This marks the opening for the teapot handle and the place where you will begin to pick up stitches with your knitting needle.

Using a 6 mm knitting needles and the 12 ply feathery textured beige and brown yarn, pick up 39 stitches from the last round of the crocheted cone. Turn and continue on these stitches.
Knit 24 rows or the required length for your teapot.
Change to 10 ply variegated yarn (and a smaller gauge needle, if you prefer a tighter rib).
Row 25: K1, P1.
Row 26: P1, K1.
Continue in rib pattern for six rows. Cast off.

BODY BACK

Pick up the remaining stitches from the opposite side of the crocheted cone and work as for the body front.

CONE DIAPHRAGM

Make a circular diaphragm to hold the stuffing in the cone section. Circles may be knitted or crocheted. Using the 10 ply green and brown variegated yarn, work a circle according to the instructions on page 107.

FINISHING

Fill the cone with polyester fibre fill and squeeze it to mould it into the desired shape. Sew the cone diaphragm to the base of the cone to contain the stuffing. Sew the front and back together at the ribbed base only.

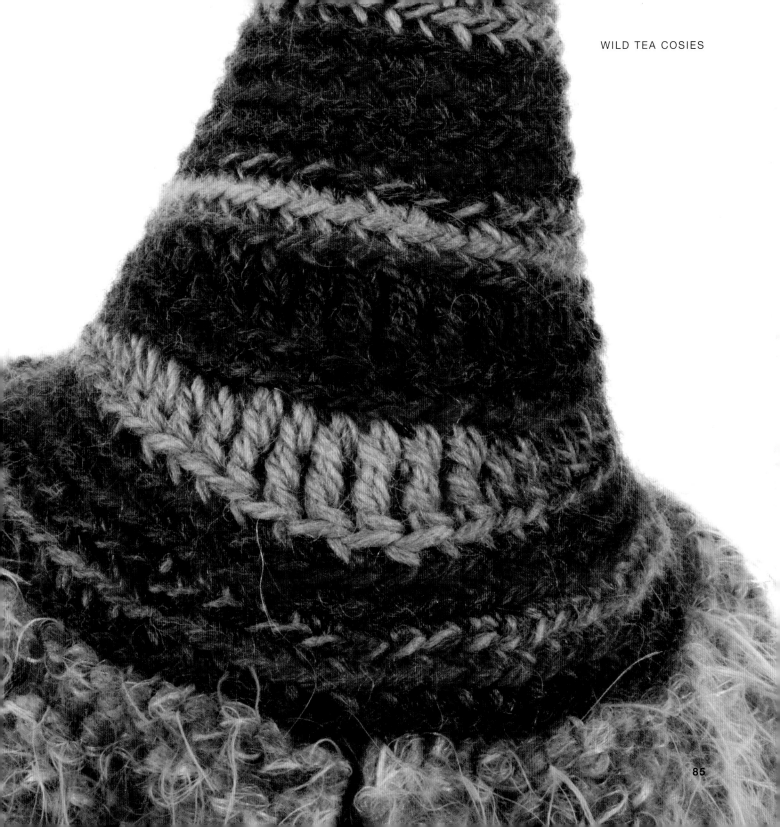

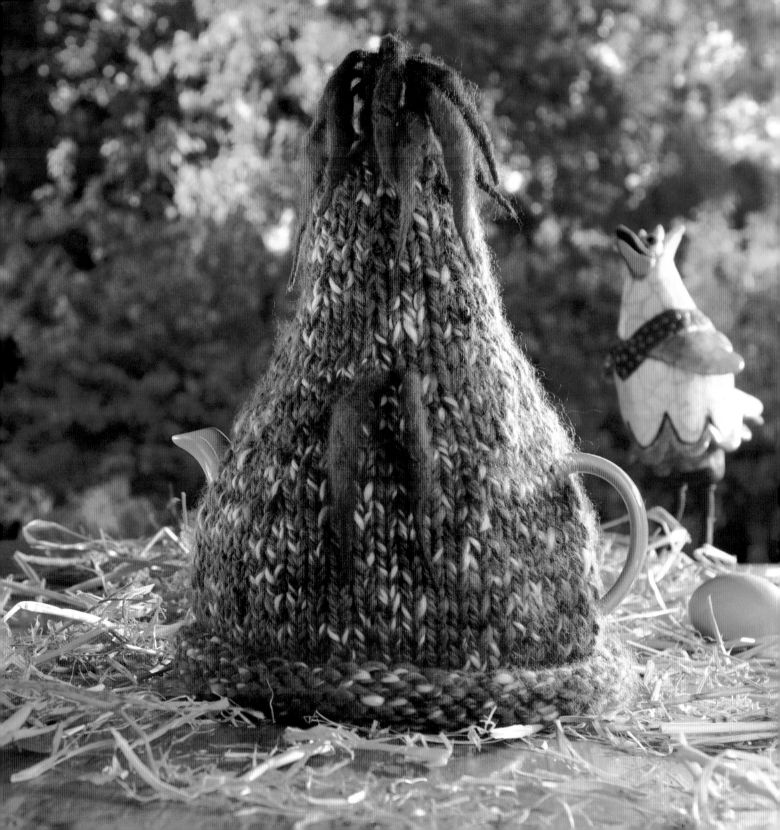

Prized Rooster

Knitted cosy

I had in mind a prized rooster when I chose the adornments to this tea cosy. They are cut from lengths of slubbed wool. You can use anything that takes your fancy from your stash. Or perhaps you are in need of an excuse to buy something a little extravagant from your wool store?

SIZE
Six- or eight-cup teapot

MATERIALS
Two 100 g balls of Rowan Chunky Print yarn, Girly Pink
OR
Two 50 g balls of 8 ply yarn, pink
Two 50 g balls of 8 ply yarn, blue
Two 50 g balls of 8 ply yarn, yellow
Small amount of Collinette Point 5 extra chunky slub yarn, cherry
Polyester fibre fill

EQUIPMENT
Five 6 mm double-pointed needles
Scissors
Darning needle

BODY
Using four 6 mm double-pointed needles and one strand of Rowan Chunky Print yarn (or 3 strands of different coloured 8 ply yarn), cast on 50 stitches — 13, 12, 13, 12 stitches on each needle. Join the cast on stitches in a round, making sure the cast on stitches are not twisted around the needles.
Rounds 1–18: Knit. Knitting in the round creates a stocking stitch fabric, which will roll up beautifully.

FRONT
Row 19: With the right side of the work facing you, knit the next 25 stitches. Turn and continue on these stitches.
Row 20: With the wrong side of the work facing you, K3, purl to last three stitches, K3.
Repeat these two rows of stocking stitch eight times or until the work measures to the top of your teapot spout and handle. Cut the yarn and tie it off.

BACK
Work on the remaining stitches as for the front. Do not cut the yarn off.

TOWER

Begin knitting in the round again, joining the front and back of the tea cosy. Knit six rounds (stocking stitch).

Decrease round 1: *K8, K2 tog*, repeat * to * to end.

Knit four rounds.

Decrease round 2: *K7, K2 tog*, repeat * to * to end.

Knit four rounds.

Decrease round 3: *K6, K2 tog*, repeat * to * to end.

Knit four rounds.

Decrease round 4: *K5, K2 tog*, repeat * to * to end.

Work four rounds.

Decrease round 5: *K4, K2 tog*, repeat * to * to end.

Work four rounds.

Decrease round 6: *K3, K2 tog*, repeat * to * to end.

Work four rounds.

Decrease round 7: *K2, K2 tog*, repeat * to * to end.

Work four rounds.

Decrease round 8: *K1, K2 tog*, repeat * to * to end.

Continue in this decreasing pattern until 10 stitches remain. Cast off.

DIAPHRAGM

Make a circular diaphragm to hold the stuffing in the tower section. Circles may be knitted or crocheted. Using the main yarn, or one strand of 8 ply yarn, work a circle according to the instructions on page 107.

FINISHING

Stuff the cone loosely with polyester fibre fill, enough to help it stand up tall. Sew the diaphragm into place taking care not to gather in the tea cosy wall. The base will roll up nicely. You can leave it to do its own thing, or you can sew the bottom edge to the last round before the spout and handle openings and stuff the roll with polyester fibre fill. **Cut** short lengths of ultra chunky slub yarn and add a cock's comb to the top of the tea cosy. Add a smaller wattle on the front and back.

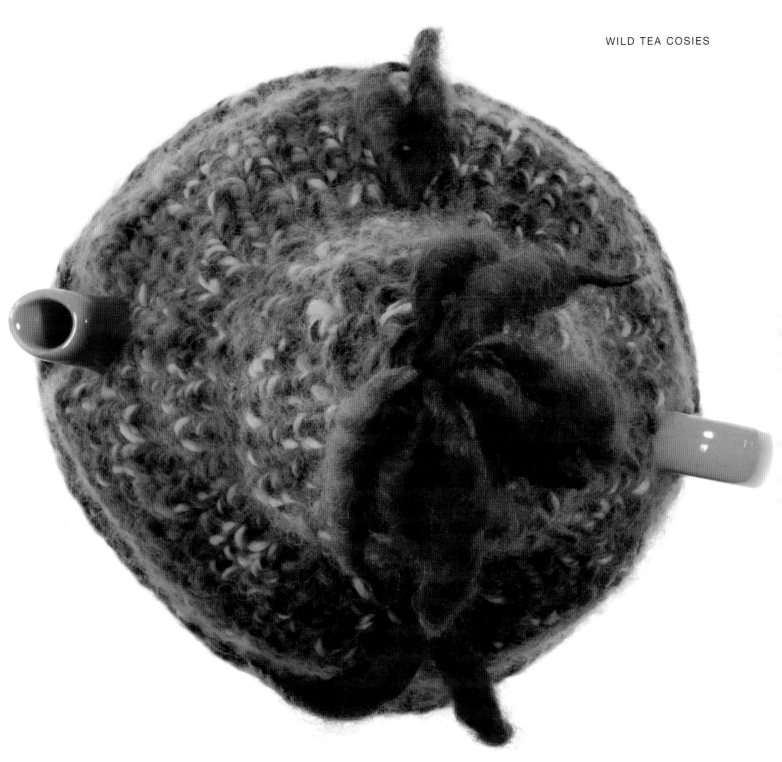

A good yarn

These designs were first exhibited in my local bookshop. I sat quietly in a corner, anonymous, watching all sorts of people looking at them. The urge to touch was too great for most. Hands sprung out, fingers tickled and teased, some not just touching but prodding and poking, working the wool like clay.

'Stop!' I wanted to scream out. 'Don't mess with my masterpieces.' But I kept my lips zipped, put on my old shoes and reminded myself that it is impossible to really know a woollen thing without touching it. Feeling it. Luxuriating in it. And I recognised those people as partners in wool.

CHOOSING A YARN

Use only the very best wool. Please. Even on a little tea cosy. Especially on a little tea cosy! Okay, okay. Wool snob exposed. The whole point of working with wool is that it's beautiful: to look at, to touch, and to knit. It's not enough that it's real wool. It has to be really beautiful real wool.

And never feel guilty about the size of your yarn stash: the bigger the better. Sometimes a yarn appeals to you, even though you don't have a project in mind. Purchase some anyway, because one day you'll find the perfect use for it.

SHOWING OFF FANCY YARN

Often the wrong side of stocking stitch gives the best effect when using a fancy yarn. Push all the fancy bits to the back of the work when in a knit row and bring all the fancy bits to the front of the work when in a purl row. The wrong side of stocking stitch becomes the right side of the fabric.

ONE BALL, TWO STRANDS

If your pattern requires two strands of yarn but you only have one ball, find the end deep down inside the ball and use it along with the outside strand.

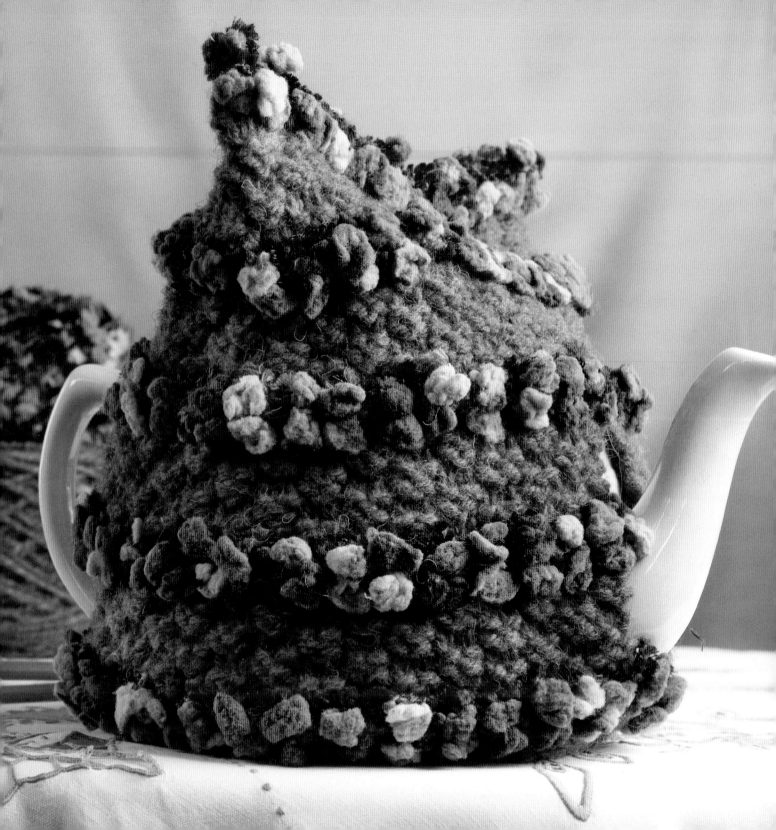

Beauty and the Beast

Knitted cosy

Like tea and biscuits, like Bogie and Bacall, some yarns are meant to star together. Mud-coloured tweedy yarn proves the perfect foil for bobbles of marshmallow pink fluff.

SIZE
Six-cup teapot

MATERIALS
Two balls of 10 ply yarn, mud brown
One ball of bobble yarn, pink

EQUIPMENT
Pair of 5 mm knitting needles
Two 5 mm double-pointed knitting needles
Scissors
Darning needle

FRONT AND BACK
Using 5 mm knitting needles and 10 ply mud brown yarn, cast on 36 stitches. Work both front and back at the same time using separate balls of yarn. The brown background is worked in a checkerboard pattern, using multiples of four stitches.

Row 1: *K2, P2*, repeat * to * to end.
Row 2: *K2, P2*, repeat * to * to end.
Row 3: *P2, K2*, repeat * to * to end.
Row 4: *P2, K2*, repeat * to * to end.

Row 5: You are now working on the right side of the knitted fabric. Change to bobble yarn and purl to the end of the row.
Row 6: You are now working on the wrong side of the knitted fabric. Knit to the end of the row.
Rows 7–16: Change back to brown yarn and continue in the checkerboard pattern.
Rows 17 and following: Repeat rows 5–16 three times. Leave the stitches on the needles.

GRAFTING
Grafting is where you knit (rather than sew) the top of the tea cosy together.
Slide 18 stitches from the front of the tea cosy onto one of the double-pointed needles. Slide 18 stitches from the back of the tea cosy onto the other end of the same double-pointed needle.
Slide remaining stitches from right and left side of tea cosy to the second double-pointed needle. Lay the two double-pointed needles one in front of the other and hold them in your left hand.
Using the bobble yarn, insert one of the single-pointed needles into the first stitch on the front needle and then the first stitch on the back needle and knit off both needles to form one stich. Repeat to the end of the row. You will now have 36 stitches on one needle.
Knit one row. Cast off knit wise.

FINISHING
Sew the side seams together above and below the teapot spout and handle openings.

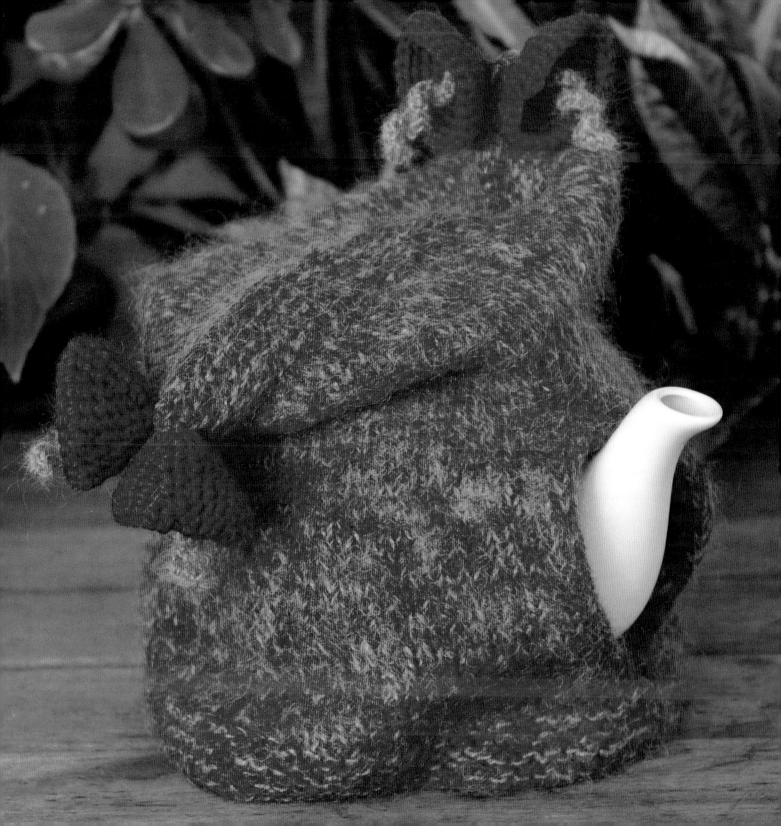

Harlequin Flower

Knitted and felted body
Crocheted flowers (or pompoms)

This tea cosy is knitted on a grand scale, to accommodate shrinkage during the felting process and to allow for a relaxed attitude as it sits on the teapot.

SIZE
Six-cup teapot

MATERIALS
Two 50 g balls of 8 ply yarn, crimson
Two 50 g balls of 4 ply mohair yarn, mandarin
Dishwashing detergent and hot water

EQUIPMENT
Five 5 mm double-pointed needles
4 mm crochet hook
Scissors
Darning needle
Washing machine
Iron
Pillowslip and towel

BASE
Using 5 mm double-pointed needles and one strand each of 8 ply crimson yarn and 4 ply mandarin mohair yarn, cast on 84 stitches. Divide the stitches evenly onto four double-pointed needles — 21, 21, 21, 21 stitches. Join into a round by knitting the first stitch and then tying a single knot using the working thread and the thread from the beginning of your casting on. Make sure the stitches are not twisted around the needles.
Rounds 1–6: Garter stitch. When working in the round you will need to knit one round and purl one round.

FRONT AND BACK
Row 9: Knit 42 stitches. Turn and continue on these stitches.
Row 10: Purl 42 stitches.
Continue working the front in stocking stitch for another 26 rows. Leave the stitches on the needles. Break off the yarn, leaving a long thread for darning later. Repeat with the remaining stitches for the back of the cosy. Do not break off the yarn.

TOP
Join the front and back together again by knitting in the round once more. Continue working in stocking stitch for 24 rounds.

TOP BAND
Rounds 61–69: Work garter stitch in rounds as for the base. Cast off.

BELL FLOWERS

Make four crocheted flowers. If you don't crochet, you can make pompoms as described on page 71. The flowers or pompoms will not be felted.

Important! When working in the round for this flower, crochet into the back of the loop only. Mark the beginning of the round with a short contrasting coloured thread.

Using a 4 mm crochet hook and crimson yarn, make 5 chain. Join the chain with a slip stitch to form a ring.

Round 1: 8 dc into ring, gathering the tail of the yarn into the stitches as you go.

Round 2: *2 dc into next dc, 1 dc into next dc*, repeat * to * to end (12 stitches).

Round 3: *2 dc into next dc, 1 dc into next 2 dc*, repeat * to * to end (16 stitches).

Round 4: *2 dc into next dc, 1 dc into next 3 dc*, repeat * to * to end (20 stitches).

Round 5: *2 dc into next dc, 1 dc into next 4 dc*, repeat * to * to end (24 stitches).

Round 6: 1 dc into next dc to end.

For a smooth finish, slip stitch into the next dc. Cut the yarn and tie off, leaving enough yarn to darn into the work.

Using a 4 mm crochet hook and mandarin mohair yarn, make 15 chain. Work 3 dc into the second chain from the hook, 3 dc into next chain to end of chain string. Cut the yarn and tie off, leaving enough yarn to attach the stamen to the flower and the flower to the tea cosy.

FINISHING

Turn the tea cosy inside out and lay it flat on a table with the spout and handle openings lying in the centre of the rectangle shape. Pin and sew the top seam together with a close overstitch.

Felt the tea cosy using dishwashing detergent and hot water. Place the tea cosy in a pillowslip, then place the pillowslip in the washing machine with dishwashing detergent and start a hot water wash. Do not let the cycle go to spin. Wash only. You may need to repeat the process two or three times, depending on the delicacy of your wool and the harshness of your washing machine, until the cosy is a suitable size.

Spread the cosy flat on a towel to dry. If you don't think it is felted enough, a steaming hot iron will help the job along too.

Sew the stamen into the flower bells and attach the flowers to the top corners of the cosy. Their weight helps the cosy maintain its floppy demeanour.

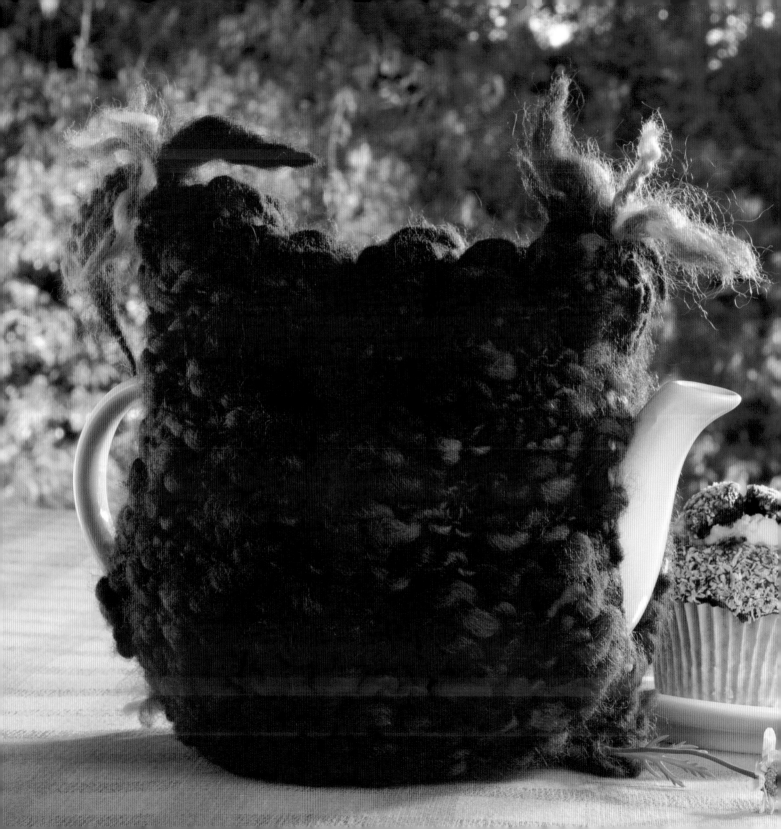

Chicken Little

Knitted cosy

I love wool. I love wool. I really love wool. Wool can make or break a tea cosy but in this design, it is paramount. In fact, it's simply all about the wool. If you can't find the Collinette Point 5 Chunky wool, any broadly slubbed wool will give the same effect. Slubbed wool is wool with fat lumpy bits along the thread. Fat, thin, fat, thin, all the way. The fatter the lumpy bits, the more striking the effect when knitted up.

SIZE
Six-cup teapot

MATERIALS
One 100 g hank of Collinette Point 5 Chunky wool, variegated magenta
60 cm each of three contrasting coloured 8 ply yarns

EQUIPMENT
Pair of 10 mm knitting needles
Scissors
Darning needle

BODY
Using 10 mm knitting needles and Collinette Point 5 Chunky wool, cast on 20 stitches. Knit every row for 60 rows. Cast off.

FINISHING
Fold the rectangle in half. Working from the bottom edge up and using the three contrasting coloured 8 ply yarns together, sew up the side seams with a wide running stitch. Remember to leave openings for the spout and handle. Running stitch is a series of even stitches with even spaces between them.
Leave a decent length of the contrasting coloured thread at the top corners. Tie a length of the Collinette yarn through the corners and fluff them up with the contrasting coloured threads to suggest the chicken's head and tail.

A DIFFERENT YARN
If you choose a different chunky, slubby yarn, guess how many stitches you will need according to the manufacturer's recommendations and start knitting. Measure it against your teapot after about six rows. If you don't think it will fit, pull it out and start again.
Alternatively, knit a gauge swatch at least 10 cm across and 10 cm long. Count the number of stitches and rows to each 10 cm, and calculate the number of stitches you will need for a tea cosy to fit your pot. This is a better method than trial and error if the yarn is fragile and won't take kindly to being pulled undone.

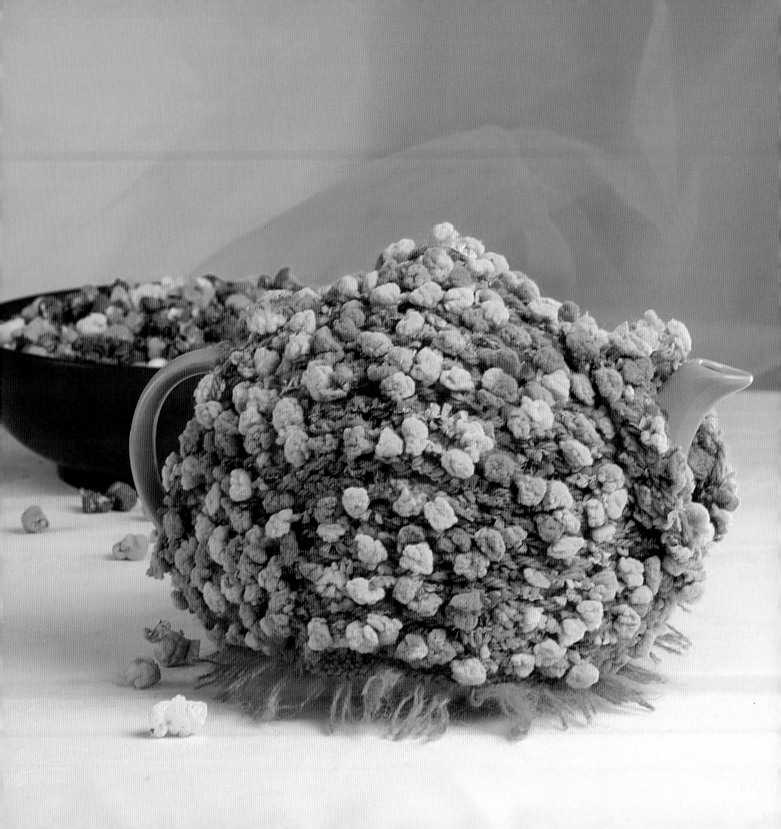

Candy Popcorn

Knit and crochet, or knit only cosy

I love fancy yarn. Giddy, dizzy, silly, fancy yarns. They do flit about a bit. Here today, gone tomorrow. Enjoy them while they're here. We can let them have their moment in the sun — their 15 minutes of fame. If, when you pick up this book the Beaumont Popcorn Rainbow has been and gone, take heart. Some new frothy thing will charm you.

SIZE
Six-cup teapot

MATERIALS
Two 50 g balls of popcorn yarn, rainbow colours
One 25 g ball of 8 ply yarn, bottle green
Small amount of 4 ply mohair yarn, tangerine
Small amount of 8 ply yarn, orange (for sewing up)

EQUIPMENT
Pair of 8 mm knitting needles
5 mm crochet hook
Scissors
Darning needle

BODY — WITH THE CROCHETED BASE
This is the version in the photograph. Using 8 mm knitting needles and popcorn yarn, cast on 20 stitches. Knit one row, purl one row. The body is knitted all in one piece so continue until the work measures up and over the top of the teapot.

FINISHING — WITH THE CROCHETED BASE
Sew up the sides with overstitch, leaving openings for the spout and handle. Use a 5 mm crochet hook and 8 ply bottle green yarn and work 2 dc into each knit stitch around the base of the body.
Rounds 2 and 3: 1 dc into each dc. **OR**

BODY — WITH THE KNITTED BASE
Using 8 mm knitting needles and 8 ply bottle green yarn, cast on 20 stitches. Knit 4 rows.
Change to popcorn yarn. Knit one row, purl one row. The body is knitted all in one piece so continue until the work measures up and over the top of the teapot.
Change to bottle green 8 ply yarn and knit four rows.

FINISHING — WITH THE KNITTED BASE
Sew up the sides with overstitch, leaving openings for the spout and handle. Use 8 ply orange yarn that will get lost among the bobbles. This yarn is particularly floppy so you may need to work a couple of gathering stitches on the shoulders to help it retain its shape.

FRINGE
Make fringe lengths of approximately 8 cm long from the 4 ply tangerine mohair yarn. Using a crochet hook, pull the middle of a single length part way through a stitch in the bottom row of the green band. Pull the yarn ends through the loop you have made and pull tight to secure. Repeat every four or five stitches around the green band.

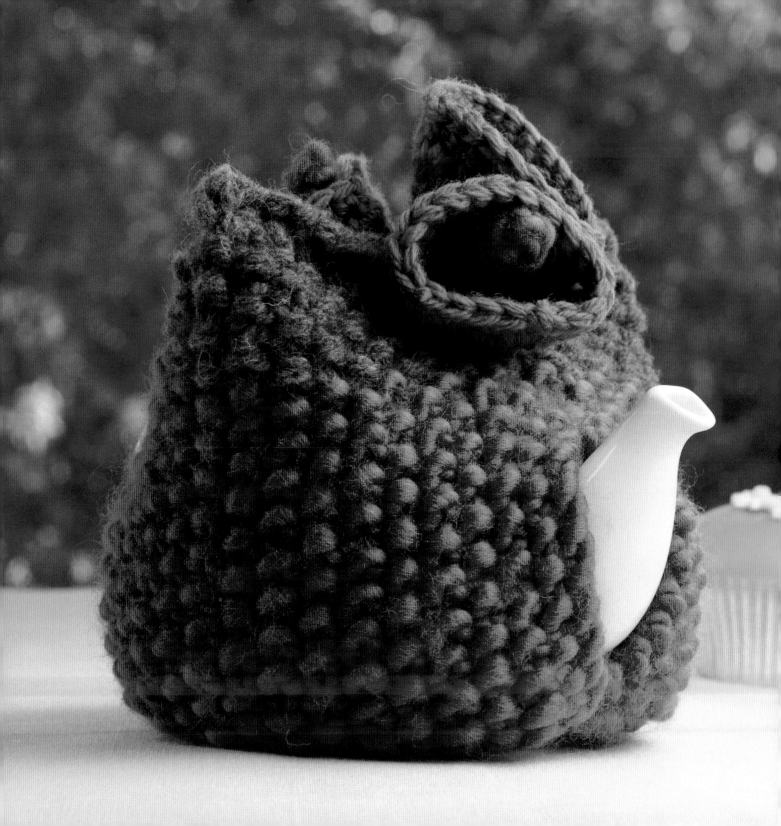

Bella Bell

Knitted body
Crocheted flowers

The beauty of Bella Bell is in her simplicity. She is made with two knitted rectangles grafted and sewn together in the same way as Beauty and the Beast. What could be simpler than that? The same but different! Imagine the number of variations on a theme possible with this one basic pattern.

SIZE
Four-cup teapot

MATERIALS
Two 50 g balls of 8 ply yarn, pink
Two 25 g balls of 8 ply yarn, grey-green
One 25 g ball of 8 ply yarn, lime green

EQUIPMENT
Pair of 7 mm knitting needles
Two 7 mm double-pointed needles
5 mm crochet hook
Stitch holder

BODY
Make two pieces: a front and a back. Find both ends of the yarn in each ball of 8 ply pink yarn and knit with these four strands, using 7 mm knitting needles. Cast on 21 stitches.
Row 1: K1, P1 to end.
Row 2: K1, P1 to end.
Repeat this two-row pattern (moss stitch), knitting the purl stitches and purling the knit stitches, for 21 rows.
Row 22: Change to four strands of 8 ply grey-green yarn and continue in moss stitch for 10 rows.
Break off the yarn and leave the stitches of the front piece on a stitch holder while you knit the back piece.

GRAFTING
Slide 10 stitches from the front of the tea cosy onto one of the double-pointed needles. Slide 10 stitches from the back of the tea cosy onto the same double-pointed needle. Slide the remaining stitches from the front and back of the tea cosy onto the second double-pointed needle. Lay the two double-pointed needles one in front of the other and hold them in your left hand.
Using two strands of grey-green yarn only, insert one of the knitting needles into the first stitch on the front needle and then the first stitch on the back needle. Knit off the from the left hand needles to form one stitch. Repeat to the end of the row. You will now have 21 stitches on one needle.
Work one row in moss stitch. Cast off moss wise.

BELL FLOWERS

Make three bell flowers. Using a 5 mm crochet hook and one strand each of the grey-green and lime green yarn (two strands), make 5 chain. Use a slip stitch to join the chain into a ring.

Round 1: 1 ch (counts as first dc), 7 dc into ring. Mark the beginning of the round with a contrasting coloured yarn.

Round 2: *2 dc into next dc, 1 dc into next dc*, repeat * to * to end.

Round 3: *2 dc into next dc, 1 dc into next 2 dc*, repeat * to * to end.

Change to two strands of lime green yarn.

Round 4: *2 dc into next dc, 1 dc into next 3 dc*, repeat * to * to end.

Round 5: 1 dc into each dc.

Slip stitch into next 2 dc for a smooth finish. Tie off the yarn ends and darn them into the side of the bell right down to the base.

Using a 5 mm crochet hook and two strands of pink yarn, make three stamens.

Make 8 chain. Make 1 htr into the second chain from the hook. Slip stitch into each of the remaining chain. Tie off the end of the yarn.

FINISHING

Sew the side seams together above and below the spout and handle openings. Stitch the stamens into the bell flowers and the bell flowers into the top of the tea cosy. Darn in the yarn ends on the inside of the cosy.

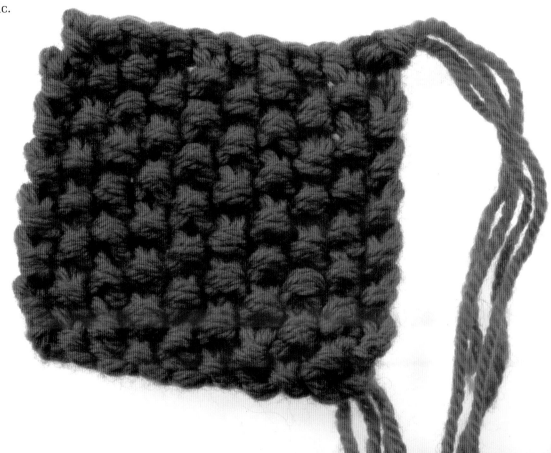

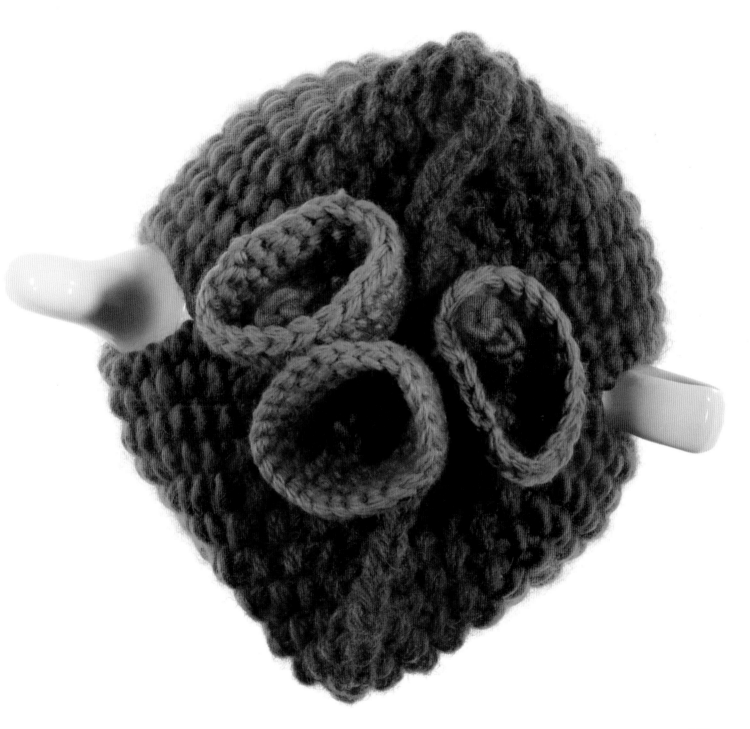

Knit or Crochet: Circles

KNITTING NEEDLES

The larger the circumference of the circle, the more stitches you will have and the more double-pointed needles you will need to use. I use up to seven double-pointed needles for the last stages of a circle with a diameter of 16 cm. You could also use a circular needle.

CIRCLE — KNITTED

Using 4 mm double-pointed needles and 8 ply yarn, cast on 14 stitches.

Divide stitches onto three needles — 5, 5, 4 stitches. Join in a round. This first round will be the centre of the circle.

Round 1: *K1, increase into next stitch*, repeat * to * to end.

Round 2 and each alternate round: Knit.

Round 3: *K2, increase into next stitch*, repeat * to * to end.

Round 5: *K3, increase into next stitch*, repeat * to * to end.

Round 7: *K4, increase into next stitch*, repeat * to * to end.

Continue in this increasing pattern until just before the desired diameter measurement is reached.

Last row: K1, P1 to end of round.

Cast off by purling the knit stitches and knitting the purl stitches. The resulting two-row moss stitch pattern stops the edges of the circle from curling up.

Run a length of yarn around the 14 stitches at the centre of the circle and draw up to close the hole.

CIRCLE WITH SOFT FRILLY EDGE — KNITTED

Work a plain circle as above. When the desired diameter measurement is reached, begin increasing again.

Frill round 1: *K2, increase into next stitch*, repeat * to * to end.

Frill round 2 and each alternate round: Knit.

Frill round 3: *K3, increase into next stitch*, repeat * to * to end.

Continue in this increasing pattern until the frill is as wide as you like. Work a two-row moss stitch edge and cast off as above.

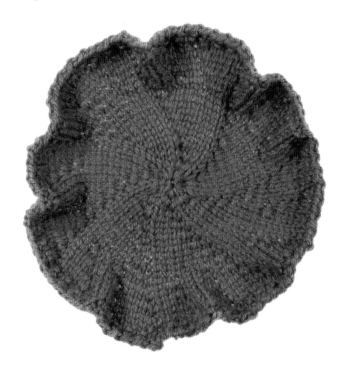

CIRCLE WITH A VERY FRILLY EDGE — KNITTED

Work a plain circle as with soft frilly edge. When the desired diameter measurement is reached, begin increasing again.

Frill round 1: *K1, increase into next stitch*, repeat * to * to end.

Frill round 2 and each alternate round: Knit.

Frill round 3: *K2, increase into next stitch*, repeat * to * to end.

Continue in this increasing pattern until the frill is as wide as you like. Work a two-row moss stitch edge and cast off as with soft frilly edge.

CIRCLE — EASY VERSION KNITTED IN ROWS

Using 4 mm double-pointed needles and 8 ply yarn, cast on 14 stitches. Divide stitches evenly between two needles. Do not join in a round. Knit back and forth in rows. Add double-pointed needles as needed to accommodate the increasing stitches. **The** cast-on stitches are the centre of the circle. As you knit up from here you are forming the radius of the circle. It is not until you cast off that the flat circle is revealed.

Row 1: *K1, increase into next stitch*, repeat * to * to end.

Row 2 and each alternate row: Purl.

Row 3: *K2, increase into next stitch*, repeat * to * to end.

Row 5: *K3, increase into next stitch*, repeat * to * to end.

Continue in this increasing pattern until you reach the desired radius (half the diameter). Knit a two-row moss stitch edge and cast off as for the plain circle. Sew the sides of the fabric together.

CIRCLE — CROCHETED

Using a 4 mm crochet hook and 8 ply yarn, make 8 chain. Join the chain into a ring by working a slip stitch into the first chain.

Round 1: 2 ch (counts as first dc), work 11 dc into the ring gathering up the tail of the yarn as you go (12 stitches).

Round 2 and each alternate round: 1 dc into each dc to end.

Round 3: 2 dc into each dc to end.

Round 5: *2 dc into next dc, 1 dc into next dc*, repeat * to * to end.

Round 7: *2 dc into next dc, 1 dc into next 2 dc*, repeat * to * to end.

Round 9: *2 dc into next dc, 1 dc into next 3 dc*, repeat * to * to end.

Round 11: *2 dc into next dc, 1 dc into next 4 dc*, repeat * to * to end.

CIRCLE WITH FRILL — CROCHETED

Work as for the plain crocheted circle. When the desired diameter measurement is reached, begin increasing again.

Round 12: *2 dc into next dc, 1 dc into next dc*, repeat * to * to end.

Round 13: 1 dc into next dc to end.

Round 14: *2 dc into next dc, 1 dc into next dc*, repeat * to * to end.

Round 15: 1 dc into next dc to end.

Round 16: 1 dc into next dc to end.

Knit or Crochet: Frill

FRILL — CROCHETED

Using a 4 mm crochet hook and 8 ply yarn, make 22 chain.

Row 1: 1 dc into third chain from hook (counts as first dc), 1 dc into each dc.

Row 2: *2 dc into next dc, 1 dc into next dc*, repeat * to * to end.

Row 3: 1 dc into next dc to end.

Row 4: 1 dc into next dc to end.

To make a frillier frill, add an increasing row, 2 dc into every second stitch, between rows 3 and 4.

FRILL — KNITTED

Using 4 mm double-pointed needles and 8 ply yarn, cast on 20 stitches.

Row 1 and each alternate row: Purl.

Row 2: Increase knit wise into each stitch.

Row 4: *K1, increase into next stitch*, repeat * to * to end.

Row 6: *K2, increase into next stitch*, repeat * to * to end.

Row 8: *K3, increase into next stitch*, repeat * to * to end.

Row 9: Purl.

Row 10: Cast off knit wise.

The knitted frill and the knitted twirl are made in the same way. It's what you do with it when it comes off the needles that makes all the difference.

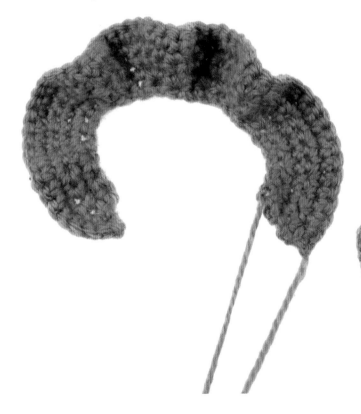

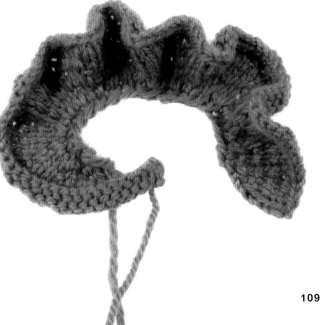

Knit or Crochet: Twirl

TWIRL — KNITTED

Using 2.25 mm double-pointed needles and 5 ply or 4 ply yarn, cast on 26 stitches.

Row 1 and each alternate row: Purl.

Row 2: Increase knit wise into each stitch.

Row 4: *K1, increase into next stitch*, repeat * to * to end.

Row 6: *K2, increase into next stitch*, repeat * to * to end.

Row 8: *K3, increase into next stitch*, repeat * to * to end.

Row 10: Cast off knit wise. Twist up the length as it is cast off the needles.

TWIRL — CROCHETED

Use a 4 mm crochet hook and 8 ply yarn.

Make 15 chain. Missing the first three chain, make 4 tr into each chain in the row.

For a longer twirl, start with 20 chain or more.

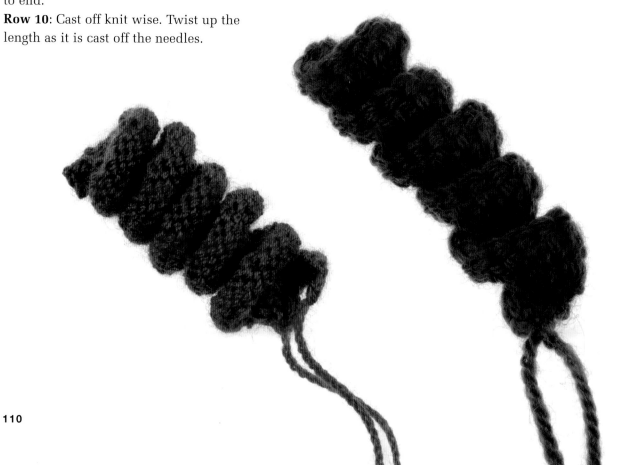

KNITTING PATTERN ABBREVIATIONS

ABBREV	INSTRUCTION
K	knit
P	purl
st(s)	stitch(es)
inc	increas(e)(ing)
dec	decreas(e)(ing)
st st	stocking stitch (1 row K, 1 row P)
garter st	garter stitch (K every row)
beg	begin(ning)
foll	following
rem	remain(ing)
rev	revers(e)(ing)
rep	repeat
alt	alternate
cont	continue
yfwd	yarn forward
yrn	yarn round needle
tog	together
cm	centimetres
in(s)	inch(es)
RS	right side
WS	wrong side
sl1	slip one stitch

CROCHET ABBREVIATIONS AND CONVERSIONS

ABBREV	AUSTRALIA / NZ / UK	ABBREV	US
ch	chain	ch	chain
sl st	slip stitch	slip st	slip stitch
dc	double crochet	sc	single crochet
htr	half treble	hdc	half double crochet
tr	treble	dc	double crochet
dtr	double treble	tr trc	treble triple crochet
triptr	triple treble	dtr dtrc	double treble double triple crochet
quadtr	quadruple treble	trip tr tr trc	triple treble triple triple crochet

KNITTING NEEDLES

IMPERIAL	METRIC (mm)	US SIZE	IMPERIAL	METRIC (mm)	US SIZE
14	2.00	0	6	5.00	8
13	2.25	1	5	5.50	9
12	2.50	–	4	6.00	10
12	2.75	2	3	6.50	10.5
11	3.00	3	2	7.00	10.5
10	3.25	3	1	7.50	11
9	3.50	4	0	8.00	11
9	3.75	5	00	9.00	13
8	4.00	6	000	10.00	15
7	4.50	7			

YARNS — GUIDELINES ONLY

UK	AUSTRALIA / NZ	USA
Double Knitting	8 ply	Sportweight
Aran	12 ply	Knitting Worsted
Chunky	14 ply	Bulky